WINSLOW HOMER

in the Clark Collection

by Alexandra R. Murphy
with contributions by Rafael Fernandez
and Jennifer Gordon

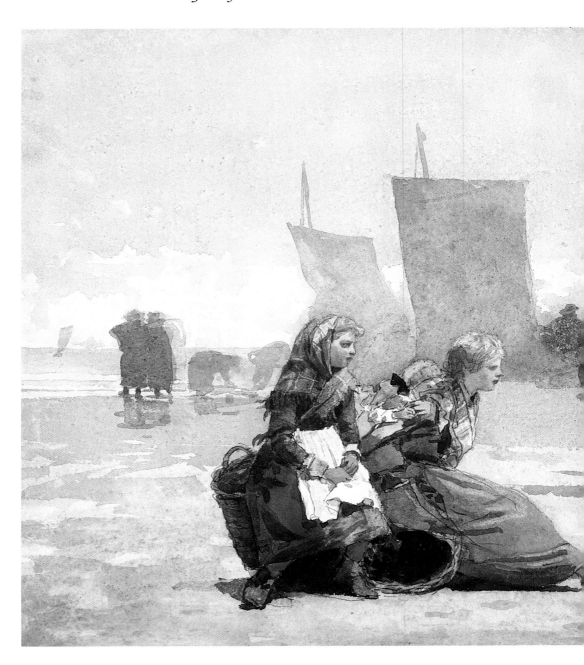

STERLING AND FRANCINE CLARK ART INSTITU

WINSLOW HOMER
in the Clark Collection

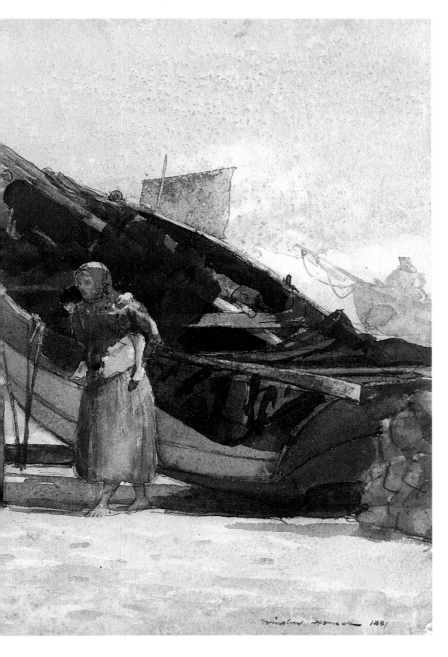

WILLIAMSTOWN, MASSACHUSETTS

CONTENTS

This catalogue was prepared to accompany the exhibition
Winslow Homer in the Clark Collection,
June 28- October 19, 1986.

Photographs by Amanda Merullo
Designed by Jonathon Nix
Printed by The Studley Press, Dalton, Massachusetts

Cover and title page: BEACH SCENE, CULLERCOATS

WINSLOW HOMER WAS ONE OF Robert Sterling Clark's favorites, and he is the artist best represented at this Institute in all the media in which he worked: painting, watercolor, drawing, etching, and wood engraving. Clark bought his first Homer, *Two Guides,* in 1916, and he continued to acquire the artist's work throughout his life. While our visitors can usually enjoy a splendid introduction to Homer in the paintings on view at the Institute, the fragility of the works on paper, and especially of the watercolors, means that these can only occasionally be seen.

The year 1986 marks the 150th anniversary of Homer's birth, and this seems a good opportunity to delight our summer and fall visitors by showing the collection as a whole. We have drawn together all the paintings, watercolors, and drawings, together with a representative sampling of the more than three hundred magazine illustrations that we own. We are also publishing this catalogue as a permanent record of our Homer holdings to give future visitors an idea of the breadth and diversity of the collection as a whole.

The exhibition is one of a series of shows which will closely examine particular strengths of our collection and is intended, as is the catalogue, for the enjoyment of the public at large.

Three members of the curatorial staff, Alixe Murphy, Rafael Fernandez, and Jennifer Gordon, have worked together closely and creatively on this exhibition and I am deeply grateful to them. Thanks are also owed to Amanda Merullo, who carefully rephotographed the Homer collection for the catalogue, and to Martha Asher, Mary Jo Carpenter, and Lucy Durkin for their invaluable assistance at so many stages of the project.

David S. Brooke
DIRECTOR

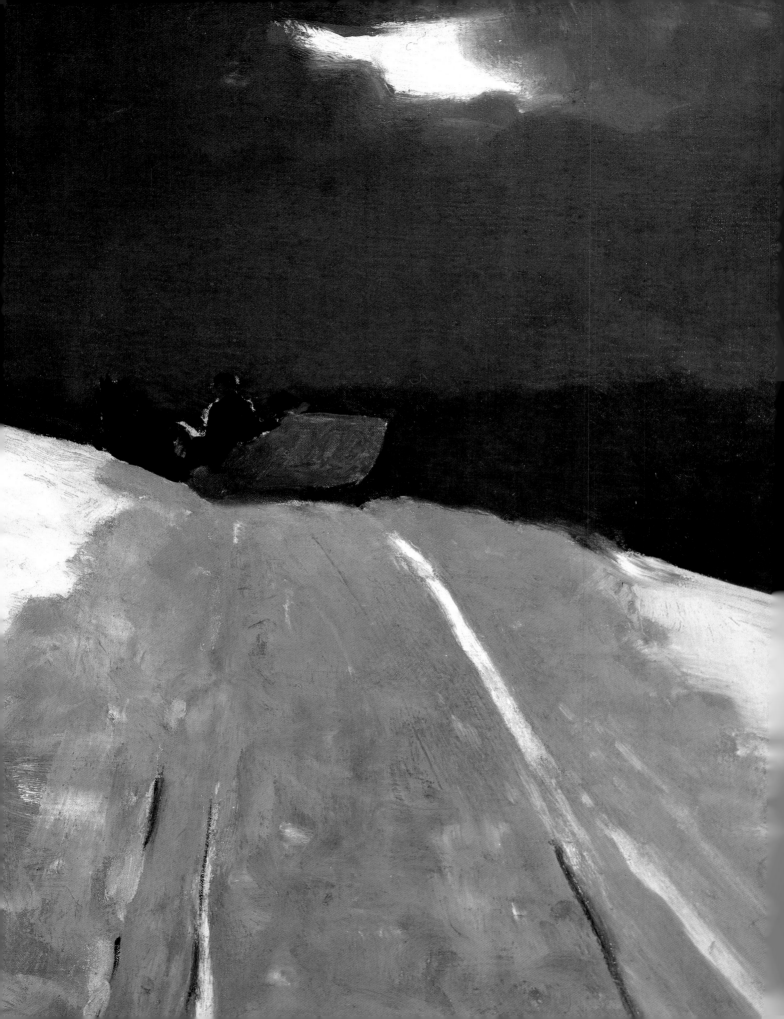

WINSLOW HOMER, AMERICAN AMONG THE MASTERS

by Alexandra R. Murphy

*"A great American artist, in the full greatness
of an art as truly American as its creator;
what words could mean more?"*

> Alfred Trumble, in
> *The Collector,*
> February 1, 1891

For many visitors to the Clark, the Winslow Homer painting which remains with them longest after they have left Williamstown is the *Sleigh Ride* (detail of cat. no. 49 on facing page), that painting of the ten in the Clark collection which fits least readily into the popular notion of Homer's art: an art of forest and sea, of rural America and the outdoor life, of children's games and deadly confrontations between man and nature; an art of straightforward naturalism.

Sleigh Ride gives little indication of locale; any action that might have been is about to pass beyond the painting itself; even the subject depends as much upon the title as on the distinctive pattern of tracks for explanation. A sleigh and its anonymous occupants disappear over an icy blue hillside shaped by three sweeping swaths of color into the bluer grays of distance. Light-struck bands of wet snow, cut into the slope by the runners, seem almost to restrain the sleigh, to hold it locked in the moonlight along the crest of the hill. A mysterious painting created of limited color and powerful forms, *Sleigh Ride* pushes a simple image of nature to the unforgettable edge of abstraction.

There is little in Homer's work before *Sleigh Ride* to prepare us for it, little in American painting that comes close to the tension of its sophisticated simplicity. Perhaps the picture with which *Sleigh Ride* can be most meaningfully compared is Vincent van Gogh's well-known *Wheatfield with Crows* (Rijksmuseum Vincent van Gogh, Amsterdam),[1] in which another dark sky, also broken by silhouettes of black birds, settles down upon broad fields crossed by diverging roads to nowhere. Van Gogh's patterned wheatstalks and radiating roads seem to move beyond the painting, closing in on the viewer's foreground space, while in Homer's picture the converging angles of hillside and sleigh tracks draw the viewer inextricably back to a precipice above an unreadable distance. By dramatically tautening the basic components of visual experience, both artists turn their backs on several decades of ever-more naturalistic landscape painting to wring from the viewer an emotional reaction, a sense of loneliness, of dislocation amidst the simplest beauty. The paintings are nearly contemporary—van Gogh's was finished just days before his suicide in 1890, while Homer's undated picture is traditionally assigned to the years around 1893.

Homer certainly never knew van Gogh's painting, and he had probably never heard of van Gogh himself. But the American and the Dutchman arrived almost simultaneously at the same point in the history of art by similar paths through a quarter century's chaos of change and challenge in the art of painting. For both artists, most of the significant signboards along the way had been in French.

Homer's paintings—whether works in oil or watercolors—were not always so well received as at the one-man exhibition which prompted the encomium by Alfred Trumble quoted at the beginning of this essay. Yet even when critics challenged Homer's work on the grounds that it was unfinished, too stridently colored, naïve, and even crude or ugly, they usually shared, with those who wrote more positively, the view that Homer's paintings were noteworthy as an embodiment of the American spirit, an art commanding critical attention because of its originality, its native strength and honesty, a truly American art.

That nineteenth-century critics should have celebrated Homer in so nationalistic—and thus, by definition, so limited—a context is not surprising; that we continue to qualify his accomplishments so narrowly today, despite the benefit of historic hindsight to help us identify the genuinely lasting artistic achievements of the nineteenth century, is more puzzling.[2] For at its best Homer's art deserves to be measured against the most advanced and challenging paintings created anywhere during his lifetime, and in its frequent references to the issues of art far beyond American shores, Homer's work itself demands such measurement.

Prior to Homer's appearance as a serious painter in the late 1860s, American art criticism had spent much of its short history lamenting the flight of American artists to France or Germany to study,

the consequent lack of a native American style, and the absence of interest in art on the part of most of the American populace. With the poor showing of American entries in the fine arts sections of the international exhibitions held in 1867 and 1878, the critical cry for a truly American art intensified.

When, after a fifteen-year career of exceptional success, Homer turned from magazine illustrations to oil paintings and watercolors of a higher level of ambition, his first exhibited pictures featured Civil War scenes, fashionable holiday excursions (cat. no. 10), and the games of country children. As he worked to master his craft, he wisely followed the common creative dictum to paint what he knew best: scenes that grew naturally out of the localized subject matter he had recorded for *Harper's Weekly* and *Appleton's Journal* during the 1860s and early 1870s. His candidacy for parochial glorification had more, however, to recommend it to nineteenth-century writers than simply the Yankee and Confederate soldiers of his Civil War paintings or the assertive Americanness of the schoolhouse (both one-room and red) in *"Snap the Whip"* (for the engraving see cat. no. 19), and Homer himself must bear part of the blame for his countrymen's failure to recognize the breadth of his ambition and his achievement.

Homer was largely self-taught. He mastered draftsmanship while an apprentice in a Boston lithographic firm, and he learned the rudiments of oil painting from a little known hack-painter in not much more than a month of Saturday mornings. He did not travel outside the country until he was already thirty and a well-established commercial artist with a modest entry into fine art successfully behind him. That initial year in France during 1866 and 1867, timed to coincide with the exhibition of two of his paintings in the American section of the *Exposition Universelle* in Paris, was followed by only one further voyage to a foreign art capital, a trip to England during 1881 and 1882. What paintings by his contemporaries or the acknowledged old masters he might have studied in Paris or London, which living artists he encountered, what work he most admired is almost entirely unrecorded. Homer seldom spoke of his travels, just as he virtually never talked about his art or his personal life. We have only his paintings from which to study his experiences.

From his pictures, however, it is clear that Homer did not bring back the usual shallow flourishes or the folderol of popular European painting that so bedeviled critics when encountered in the work of other returning Americans. His travels

did not seem to change his art, merely to strengthen it. Homegrown, committed to American values, and impervious (or so it seemed) to European notions, Homer must have appeared a most promising savior to many of the writers who had been awaiting that "new and sublimer advent of Art"[3] which could only be realized in a New World. In 1877 one of those critics could write,

Winslow Homer paints with an apparent unconsciousness of all schools of Art, and of every method other than his own. No reputation, however authoritative, ever seems to reflect a tint upon his canvas, and no influence, however powerful, is seen to alter the sweep of his brush by a hair's breadth.... He is wholly in sympathy with the rude and uncouth conditions of American life; he likes the men, the women, the boys, and the girls of the rustic by-ways of our land—and he likes them as they are, awkward in dress, spare in form, tanned and freckled by the sun, with no sensuous warmth, no dream of beauty.[4]

Freckled by the sun, awkward in dress, even rude and uncouth Homer's figures certainly were— Henry James, in fact, called his paintings "damnably ugly,"[5]—but naïve and untutored his art was not. The notion that no other artist's example, no other influence than his own independent spirit lay beneath Homer's art is untenable. In 1877 Homer was simply several steps ahead of his critics and would remain so for the rest of his career.

Homer had been vitally involved with European art from the beginning of his career. Whether as a copyist or an adapter, he learned early on that despite regional dialects and national accents, art is a universal language. At the same time, he could hardly have failed to notice, despite the hullabaloo (or, perhaps, because of it) raised by American art writers and critics about the need for a truly American art, that the greatest laurels as well as the steepest prices still went to European artists. As he shaped his own career, he relied frequently on European models for inspiration as well as for challenge. That this reliance has so often gone unrecognized or been minimized reflects an unnecessarily exalted understanding of the artistic process as well as misdirection in the search for Homer's sources.[6]

While early in Homer's painting career the nativism of his subject matter certainly masked his reliance on European sources, from the 1880s on his paintings had little more to do with American life than incidental setting, and even then he didn't hesitate to people American landscapes with figures dressed in English costume (see, for instance, the Prout's Neck residents posed as Cullercoats fisherwomen in *Sunset, Saco Bay,* cat. no. 51). From *The*

Life Line (Philadelphia Museum of Art) of 1884 until his death in 1910, Homer's most ambitious pictures were addressed directly to those constant themes—life and death, man's measure within God's creation, the interlocking contradictions of power and beauty—that have defined art universally. At the same time, his greatest paintings grapple with the most demanding stylistic issues of his age. The stage on which Homer presented his art to the public was an international one, not simply an American one.

The process of borrowing and adaptation that would shape Homer's career was already well established in one of his earliest works—a humorous drawing of 1849, depicting his father's departure to join the gold strike in California. The childish work (Museum of Fine Arts, Boston) borrows from a Currier lithograph entitled "The Way They Go to California" the most striking feature—a traveler mounted on a rocket, top hat flying behind him—and combines it with incidental stick figures poised on mountain and rooftop by Homer himself.[7]

As a boy Homer studied figure drawing by copying lithographic instructional plates his father sent from England—in the same way art students in London and Paris began—and at Bufford's lithography firm, as an apprentice, he routinely copied or adapted illustrations by British contemporaries (as well as all manner of photographs) with no apparent qualms about affixing his own name to these hybrid designs (see cat. no. 1). It is highly likely that later, for the precise details and up-to-the-moment furbelows of the beautifully-clad American girls in his *Harper's* illustrations, Homer would have had as much recourse to the fashion magazines of the day—which could be counted on to stand still long enough for a careful rendering—as to the young women of his acquaintance, just as Monet, Renoir and Cézanne did on occasion during the same years in France.

To stress such points is not to minimize the originality of Homer's art. Indeed, his extraordinary inventiveness and his unparalleled ability to find the picturesque possibilities in the most mundane visual experience are the two most important of Homer's natural gifts as an artist. The capacity to invent entertaining designs week after week for the magazines should never be underestimated, for it cannot be taught.

What can be taught, however, are the skills of composition and draftsmanship, and Homer acquired them slowly, in exactly the same fashion as his contemporaries at home and abroad. In doing so, he established a habit familiar to virtually every artist: the routine study of any and all forms of prints and reproductive materials—whether for example, for inspiration, or for precision in detail.

Learning by copying and creating by adapting are far more basic to the artistic process than is generally acknowledged, for progress or invention occurs no differently in painting than in other fields of human expression. Very little that is new has ever been created out of whole cloth, and most advancement proceeds in a complicated series of steps from and around the accomplishments of a predecessor.

As a graphic artist Homer had been truly eclectic, variously influenced by English engravings, Japanese woodblock prints, and French lithographs. The song sheet illustrations (see cat. no. 1) of his apprentice years were frequently copied from recently published English prints, with costumes and settings adapted to American taste, while much of the novelty of design in his most striking *Harper's Weekly* illustrations has been attributed by many writers to his contact with Japanese prints (cat. nos. 4, 6, and 12). As a painter, however, Homer turned almost exclusively to the art of France for models and for challenges. He was hardly alone in doing so. In the course of the nineteenth century France had established an artistic hegemony—trimphantly celebrated at the *Expositions Universelles* of 1855, 1867, and 1878—virtually requiring that any painter of real ambition be aware of and prepared to reckon with the art of Paris.

However, Homer's pattern of recourse to other artists is a complex one. Unlike most European-trained painters, he did not look automatically to the great masters of the past for inspiration and instruction but generally favored the most talented among his conventionally successful contemporaries. In particular he borrowed from those French artists whose subject matter paralleled his own and whose stylistic interests balanced naturalism with expressive color and paint handling. Of necessity (but most important, for the fact has so often been overlooked), he borrowed from those artists who had achieved sufficient commercial success to make their works accessible to him. He was not especially attentive to the most avant-garde of his contemporaries; his profound involvement with the work of Gustave Courbet, for instance, did not take hold until the years following Courbet's death, as the work of the once-renegade French artist became increasingly popular, and he took no practical notice of the Impressionists.

Homer seldom lifted material from his sources whole, as his less gifted colleagues were wont to do; rather, he pulled from those paintings that im-

pressed him the most striking and inventive characteristics, mastered them, and then fit them to his own purposes. Often his debt to other artists becomes evident only in patterns evolving through several related paintings.

In creating his early paintings, Homer searched other artists' interpretations of his own favored subject matter for effective compositions and for the most up-to-the-moment attitude toward the themes at hand. Increasingly, however, Homer's purposes were redefined by the experience of looking and borrowing. As he mastered the technical skills of painting and established his own stylistic integrity, his references to the work of other painters became directly competitive. By the time Trumble remarked on the natural Americanness of Homer's art in 1891, the artist was already fully committed to exploring the aesthetic problems that wracked the Parisian art world during the 1890s: the conflicting demands of naturalism and abstraction, the search for means to embody significant emotional content in works of art insistent upon their own materiality, and the balance between painting as a decorative art and as an intellectual expression. Three of the four oil paintings in that 1891 exhibition (*Summer Night,* Musée du Louvre, Paris; *Winter Coast,* Pennsylvania Academy of Art, Philadelphia; and *Sunlight on the Coast,* Toledo Museum of Art) have far more in common with European painting of the period than with anything else being done in America.

That Homer so thoroughly succeeded in making the French aesthetic debates about color, space, and decorative design as well as the French norms of painterly ambition so comfortably his own that their origins have usually gone unchallenged is a tribute to the exceptional originality of his art. It is, however, also a reflection of a longstanding American determination to emphasize the nationality of its heroes above the universality of their human triumphs. In failing adequately to recognize the predecessors on whom Homer most relied, we fail to appreciate the complexity of the goals to which he aspired. What is lost in viewing Homer's achievement entirely in American terms is an appreciation of the real breadth of his accomplishment.

For instance, Homer's earliest paintings, Civil War subjects, owe a significant debt to the most successful military painter of his day, Ernest Meissonier. Widely reproduced and popular in America, Meissonier's works—skillfully executed Napoleonic and Crimean campaign scenes that skirted the bloody realities of combat in favor of the activities of camp life, without the pathos or heavy-handed humor that dominated other military genre painting—commanded the highest prices paid for contemporary painting during Homer's lifetime. For a young artist portraying another war on another continent, the readily available engravings after Meissonier's works provided the most obvious and the most modern examples from which to learn, as well as the standard to be bested. Homer's *Pitching Horseshoes* (Fogg Art Museum, Cambridge) of 1864, showing off the Zouaves' colorful uniforms, is based directly on one of Meissonier's most famous military 'costume' pieces, *Sunday Morning* (1850, present location unknown), depicting eighteenth-century soldiers engaged in a similar game, while their compatriots watch from a bower behind them, as do the cooks in Homer's painting. Meissonier's willingness to chronicle defeat as well as victory probably helped legitimize Homer's first significant success, *Prisoners from the Front* (Metropolitan Museum of Art, New York), a sympathetic view of a rag-tag band of Confederate troops.

But more important than confirmation of his subject matter, Homer found in the French artist's work a strong commitment to realistic detail as well as stylistic devices that emphasized the unposed, contemporary character of his compositions. Homer adopted from Meissonier a featureless horizon, unlimited at either edge, with figures aligned along the picture plane, virtually in the viewer's own space; the directness and immediacy that result strongly enhance the viewer's sense of an event observed. Homer's frequent reliance on this type of composition for his farming scenes of the 1870s contributes substantially to the apparent naïveté so often remarked by reviewers.

Scholars have frequently related Homer's turn to farming subjects to the controversial paintings of French peasants by Jean-François Millet, despite the lack of stylistic or thematic similarities in their work. It is far more likely that Homer's attention was drawn to rural scenes by the much greater popular success and official recognition accorded another French peasant painter (himself deeply dependent on the work of Millet), Jules Breton, whose example directly underlies one of Homer's most famous post-Civil War paintings, *The Veteran in a New Field* (Metropolitan Museum of Art, New York). Swinging his scythe, Homer's veteran, back to the viewer, is centered against the verge of a stand of grain, repeating a composition used by Breton in a painting of 1857, *Departure for the Fields* (current location unknown), a picture commissioned and reproduced by one of the century's most successful international art dealers, Ernest Gambart. Homer must have known a reproduction

of Breton's work before his trip to France, as *The Veteran* is dated 1865, but two paintings executed in France in 1867 indicate that he strengthened his acquaintance with Breton's paintings in the originals at the *Exposition Universelle*—where the French painter's gold medal and designation as an Officer of the Legion of Honor at age forty attracted considerable attention. Breton's work would have reinforced Homer's attraction to Meissonier's shallow picture spaces emphasizing a small number of foreground figures; it also sensitized him to a far wider range of atmospheric effects and startling color juxtapositions, as well as to a broader, less finicky, manner of paint handling.

Either during his visit to France or at one of the exhibitions of French painting organized by the French dealer Cadart and held in New York and Boston during 1866 and 1867, Homer's interest in themes of contemporary recreation must have drawn him to the works of Eugène Boudin, for the American's first drawings of similar subjects[8] depict groups of women and children, protected by umbrellas, posed in a frieze-like arrangement that is virtually synonymous with the French artist's work. Umbrellas, well-dressed women, children, and sand were as characteristic of the beaches of Long Branch, New Jersey, in the 1860s as of those of Trouville, Normandy—it is not the similarity of subject matter that argues for Boudin's influence on Homer but the repetition of composition and the firm dependence on Boudin's color schema that turn up in Homer's paintings of the subject. Homer soon moved beyond the spatial simplifications that characterize Boudin's work, but his palette for the Long Branch paintings and the contemporary White Mountains scenes (see cat. no. 10) retained the high-keyed, sunlit tonality, punctuated by sharp, clear color details in the foreground, that characterized pre-impressionist naturalism in France.

The artists to whom Homer turned in the 1860s and 1870s—Meissonier, Breton, Boudin, and, among others, Constant Troyon and Emile Lambinet—are today less esteemed than their more controversial contemporaries, J.-F. Millet, Gustave Courbet, and Edouard Manet—but in Homer's time they were highly successful, often greatly admired, and, most important, considered to be extremely progressive forces in modern French painting.[9] Although we now recognize them as rather conservative artists working at the periphery of painterly revolution, they were nonetheless highly talented, and their work provided Homer with a systematic exposure to developing French notions about color and composition, as well as attitudes toward recording the modern world, that he is unlikely to have acquired had he concentrated only on the most avant-garde artists of the day. That Homer looked to their example reflected his ambition to compete with the best artists of his own age.

The 1880s saw Homer's energies divided between his work in watercolor (for which English artists, whose mastery of the technique was universally recognized, provided his most important sources; see cat. no. 29) and a small number of large, complex, and very ambitious subject pieces, among them the Clark's *Undertow* (cat. no. 40), that are unlike anything he had previously attempted. Celebrating contemporary acts of heroism with a forthright commitment to the details of modern dress, paintings such as *Undertow* or *The Life Line* (Philadelphia Museum of Art; for Homer's etching of the subject see cat. no. 32) turn from the anecdotal immediacy of earlier works toward the monumentality and universality associated with more traditional history paintings. Their emphasis on powerfully rendered human figures in simplified settings reflects two centuries of European and specifically French commitment to the Grand Tradition as the ultimate measure of artistic achievement, while the bathing shoes and striped swimming trunks of *Undertow* provide a forceful answer to Baudelaire's cry (still resounding in Parisian art circles some forty years after its first expression) for "A Painter of Modern Life" who would be capable of rendering the true meaning of the nineteenth century while remaining attentive to the details of top hats and black coats.[10] Homer's masterpieces of the mid-1880s assert the confidence and direction of a genuinely independent artist grappling with thematic and stylistic issues of utmost complexity within his own independent idiom—an idiom whose defining terms of composition and color had been established in the less venturesome works of the previous decade.

As Homer's art came fully into its own in the last years of the nineteenth century, he established himself firmly in opposition to the international impressionism sweeping out from Paris. Secluded in Prout's Neck, he committed himself to a powerful landscape art that defied Impressionism's emphasis on the momentary and the transitory in favor of a more classical belief in the permanence and comprehensibility of natural experience. As with the post-impressionist movements developing in and around Paris in the 1890s, Homer sought to create an art that preserved a place for the temporal, sensual, and emotional content precluded by Impressionism's determined commitment to specific vis-

ual experience yet also recognized the substantial aesthetic gains won by impressionist battles over color, two-dimensional design, and expressive brushwork.

The principal presence behind Homer's art in these last decades was Gustave Courbet, whose impassioned paintings of hunting scenes and the power of the sea made him an ideal challenge for an American artist who had increasingly isolated those subjects as the core of his artistic commitment. Although several authors have speculated that Homer visited Courbet's one-man exhibition, staged in protest outside the grounds of the *Exposition Universelle* in 1867,[11] they have searched in vain for specific traces of the French artist's influence on Homer's work in the immediately following years. Indeed, only one of Homer's paintings can be considered dependent upon the French artist in the same way earlier works derived from Breton or Meissonier: *Promenade on the Beach* (Museum of Fine Arts, Springfield, Massachusetts). And it is a particularly intriguing comment on Homer's creative process that that painting, which argues forcefully that such a visit actually did take place, was not executed until 1880. Both the exceptional composition of *Promenade,* with three-quarters of the canvas given over to sky above an almost undifferentiable strip of sea, and the unusual pairing of intense turquoises and blue-blacks derive directly from Courbet's Etretat seascapes. Only at the 1867 exhibition, which included ten such scenes (almost alone among his works in never having been admired or collected in this country) could Homer have encountered the flat, strikingly simple compositions and heightened color effects which characterize those seascapes; yet so severe is their impact even today that it is more than idle theorizing to speculate that Homer might have held their memory for thirteen years.

For the rest of his life, Homer's intercourse with Courbet's art is of a very different nature. *The Fox Hunt* (Pennsylvania Academy of Fine Arts, Philadelphia), for example, the largest and probably the greatest of Homer's paintings, reworks one of Courbet's most striking pictures, *A Fox in the Snow* (1860, Houston Museum of Fine Arts) in a much more deliberately competitive way. Homer probably saw Courbet's picture during his final days in Paris in 1867, just before it went on the auction block in January of the following year.[12] Both Courbet and Homer featured a bright red-orange fox, dramatically splayed across a white expanse of snow, with a black forepaw stretched out in dramatic counterpoint. But Homer's is a painting of 1893. He reduced the characteristic massiveness of Courbet's rocky setting to a sequence of flattened transitional elements uniting the shallow foreground with the sky, and he emphasized the powerful, patterned presence of the carnivorous birds that are only hinted at in the French picture, creating a painting that is at once more decorative and more violent than Courbet's work.

Most of Homer's work at Prout's Neck would concentrate on the sea in its most definitive image, waves breaking against rocky shores, an image as commonly characteristic of Homer's coastal retreat as it was powerfully emblematic of the waning nineteenth century. Breaking waves are one of the definitive icons of French painting between 1850 and 1900, with any painting of the theme calling up the complementary examples of Hokusai—whose *Great Wave* became symbolic of the design and decorative issues taken up by Western artists largely in response to Japanese prints—and Courbet—whose many *Wave* paintings were synonymous with the emphasis on material technique and an assertive painterly surface that so characterized avant-garde painting in the period.

In Homer's last paintings such as *Eastern Point* and *West Point, Prout's Neck* (cat. nos. 54 and 55) or *Summer Squall* (cat. no. 57), he combined shallow, decorative designs of unusual simplicity and boldness with brushwork as powerful and physically self-conscious as Courbet's own and a range of color effects possible only in the wake of Impressionism. The resulting paintings merge the romantic and the aesthetic strains of nineteenth-century expression in a fuller experience of the grandeur and beauty of the sea than ever realized by any other artist.

Perhaps in 1891 Trumble's rhetorical question, "What words could mean more?" required no answer; but now the time has come to reaffirm the critic's admiration for Winslow Homer with the simple correction,

A great artist.

FOOTNOTES:

1. I am indebted to a colleague, Ralph Lieberman, for calling my attention to the parallels with van Gogh's painting.

2. See, for instance, the opening sentence of the catalogue for the superb exhibition of Homer's watercolors held recently at the National Gallery, singled out only because of its timeliness: "Winslow Homer's watercolors have, almost from the time they were made, been ranked among the greatest achievements in American art." Helen A. Cooper, *Winslow Homer Watercolors* (Washington, D.C.: National Gallery of Art and Yale University Press, 1986), p. 16. Only the American version of the large exhibition, *Post-Impressionism* (National Gallery of Art, Washington, D.C., 1980), which in fact included *Sleigh Ride,* accommodates Homer in an international context straightforwardly and without apology.

3. Augustine Duganne, *Art's True Mission in America* (New York: George S. Appleton, 1853), p. 28.

4. *Art Journal,* May 1877, quoted in Lloyd Goodrich, *Winslow Homer* (New York: Macmillan Company, 1944), pp. 70-71.

5. Henry James, "On some Pictures Lately Exhibited," reprinted in John L. Sweeney, ed., *The Painter's Eye; Notes and Essays on the Pictorial Arts by Henry James* (Cambridge: Harvard University Press, 1956), p. 97.

6. See, for instance, William Howe Downes, *The Life and Works of Winslow Homer* (Boston: Houghton Mifflin, 1911) pp. 59-60, or Goodrich, op. cit., pp. 39-41. Albert Ten Eyck Gardner, one of the few writers on Homer to argue strongly for the significance of Homer's trip to Paris, recognizes the amount of French art theory that Homer imbibed but specifically dismisses the more popular artists as sources, preferring to stress the influence of Edouard Manet and Japanese prints. *Winslow Homer* (New York: Clarkson N. Potter, 1961), pp. 89-118.

7. Sue Welsh Reed, "Winslow Homer's Rocket Ship," *Yankee,* February 1970, pp. 74-75, 118.

8. For example, one at Yale University Art Gallery, another in a private collection. See also an East Hampton oil painting sold at Sotheby's, New York, October 22, 1981, lot 54.

9. In this company Boudin's role is somewhat anomalous, as he was hardly a significant commercial success at the time Homer encountered his work. But the inclusion of several Boudin beach scenes in both the Cadart exhibitions may well have given uncommon importance to his art.

10. Baudelaire's essay is most easily accessible in Jonathan Maynes, trans., *Charles Baudelaire: The Painter of Modern Life and Other Essays* (London: Phaidon, 1964).

11. In addition to the authors cited at n. 6 above, see also the chapter on Homer in Barbara Novak, *American Painting of the Nineteenth Century* (New York: Praeger, 1969), pp. 165-90.

12. *A Fox in the Snow* is also one of the small number of Courbet works available during Homer's lifetime in a lithograph, issued during his stay in Paris in 1867.

WINSLOW HOMER, PRINTMAKER

by Rafael Fernandez

THE SIGNIFICANCE AND SPECIAL ROLE of graphics in Winslow Homer's oeuvre have occupied and interested all those who have studied him. In 1958 Albert Ten Eyck Gardner, who wrote well and sensitively on Homer, could say in his fine introductory essay for an important Homer retrospective,

> Homer's etchings done in the 1880s seem only to have had a very brief moment of popularity and they have since suffered the same fate as all the other big etchings and steel engravings of that day. No one seems to know what happened to all those grand treasures, so vast in size, with their creamy margins punctuated with apt vignettes. Where are all those signed proofs on elegant sheets of handmade paper?[1]

Scarcely ten years later, perhaps as a consequence of renewed interest in Homer and in American art and prompted by the 1958 retrospective and other efforts at reexamination and reevaluation, Lloyd Goodrich could write eloquently about Homer as printmaker. In an exhibition catalogue for a large selection of his oeuvre at the Museum of Graphic Art in New York, Goodrich seems to describe a confirmed master.[2] Still, almost two decades after the New York exhibition, a scholarly catalogue raisonné studying surviving proofs, itemizing states, and analyzing the problem of Homer restrikes has yet to be written.

First we should consider the rather primitive and clumsy lithographs executed while he was working for the Boston workshop of J.H. Bufford (see cat. no. 1). These early efforts do not reveal the quality of Homer's later work in the medium, especially the skill of the unsigned but delightful *Union Pond* (1862) and the expertise shown in the *Campaign Sketches* (1863). Why lithography seems not to have become a favorite and satisfactory medium for Homer is a puzzle.

The second grouping of his works is a large number of wood engravings. After leaving Bufford, Homer began his career as a free-lance illustrator for the magazines *Ballou's* and *Harper's,* which required a ceaseless flow of illustrations of all kinds destined for a mass audience. Homer carefully preserved his independence by remaining a free-lancer

or (later during the Civil War) a special correspondent (see cat. nos. 3 and 4); he was never a permanent staff artist. From the beginning his inexhaustible inventiveness, freshness of vision, and capacity to work within the limitations of the medium were all evident. During the Civil War Homer was briefly with the Union Army in Virginia; it is at this time that he made many of his most memorable drawings, some of which parallel the paintings that would eventually gain him an international reputation and which were executed from those quick sketches in the battlefields and the army camps that he visited.

It is important to understand the limited role of the designing artist in nineteenth-century magazine illustration. The accepted practice was for him to draw on a specially prepared block of boxwood. Then an artisan or artisans (if the block was large it could be divided into sections and farmed out to several different engravers; note the distinct block lines in cat. no. 15, for instance) would cut the design and ready it for printing. Sometimes the artist provided, on special sheets of paper, drawings which would then be translated onto the surfaces of the blocks and cut. Homer never cut or engraved his own designs, but he was obviously quite aware of the exigencies and deficiencies of the medium and very aptly tried to circumvent them. Around 1865 photography entered the picture, allowing drawings to be photographed and printed onto sensitized blocks. The identity of many of the wood engravers is not known, but there are quite a few illustrations which are cosigned by Homer with the artisan who cut the block (for instance, cat. no. 14).

Homer made a good living with his work and was able by 1866 to devote more time to painting as well as to spend most of 1867 in France on a long holiday. While in Paris he sent home a few illustrations which were published and are justifiably famous (cat. nos. 7 and 8). During the early seventies, the period in which he started to work steadily as a watercolorist, Homer produced a large number of designs for wood engraving, not only for magazines but also for the sentimental novels of the

day. In 1875 his last contribution to *Harper's Weekly* was published. There had been a subtle stylistic change in his wood engraving during this period; it had become less linear and more tonal in quality. Some of the 'Japanese' quality in the earlier works, so admired at a later date by students of Homer, especially by Albert Ten Eyck Gardner, tended to give way to a more painterly style. It is possible, too, that the artisans who cut the blocks had become more artistically ambitious and expert, and that spatial relationships and textures which had been avoided or even ignored in the past were now given more relevance. It is doubtful that Homer thought of his wood-engraved works as more than a source of income, a way of making a living which he left behind when he found he could survive, and survive well, by selling his paintings and watercolors.

In 1881 and 1882 Homer allowed himself a long sojourn in England. Much of his time was spent in Cullercoats, a small fishing village far from the hustle and bustle of London, but he was in London long enough to make a famous watercolor of the Houses of Parliament. London was at the time a great center of print dealing and collecting, and the large auction houses periodically held sales of prints. Some American artists such as Frank Duveneck had successfully exhibited and sold in London, and in the early '80s James McNeill Whistler, the great expatriate American artist, had just succeeded in mending his fortune with the prints he had produced in Venice. The practice of translating a painting or watercolor into a print had been a moneymaking device since at least the days of Hogarth.

It is possible that Homer was aware of all these facts and realized that his very popular sea pictures could, when made into prints, become a comfortable source of income. Did he also want to reach a wider audience, as Goodrich speculates?[3] He had already had the widest audience any artist could have with the wood engravings, some of which were after his own paintings and watercolors of the seventies.

In any case, he began in 1884 his first successful etched plate, *Saved* (cat. no. 46), based on his painting *The Life Line*, just after the painting was exhibited and sold. He had had no formal training as an etcher (an early etching generally dated about 1875 and representing a model in a chair is just an essay and cannot ever have been considered a salable item). Homer learned much from George G.H. Ritchie, a printmaker who worked in New York.[4] The practice adopted by Homer was to have Ritchie put a preparatory etching ground on the plates and

mail them to him. Homer would draw his design on the prepared plate with a metal etching needle, cutting through the layer of ground. When the composition was complete, Homer would submerge the plate in an acid bath to "bite" the metal exposed by his drawing. This would make the lines deeper and sharper, while the surface of the plate covered by ground would be protected from the acid. Because he did not have access to a press, Homer sent the etched plates back to Ritchie, who printed the etchings. Ritchie then returned the plates along with trial proofs to Homer, who would do whatever reworking he deemed necessary, which was often considerable. Finally, the plates went back to New York for the printing of the edition.

Ritchie, not being a dealer, did not succeed in selling Homer's prints to the satisfaction of the artist, so about 1887 Christian Klackner, a New York print dealer and editor, signed an agreement with Homer.[5] As Goodrich points out, Klackner also sold photogravures after works by Homer and made no distinction between them and the etchings in his promotional circular.[6]

What becomes clear after studying Homer's etchings is that, although indebted to his works in other media, they are individual statements, related to but in no way subservient to or dependent on the generating work. It is illuminating to compare a version by James D. Smillie, done at the request of Sylvester Rosa Koehler, of Homer's watercolor entitled *A Voice from the Cliffs,* to be used as an illustration for Koehler's book, *American Art*. Smillie's etching uses all the popular devices of the day; the women are pretty and the tonal effects accentuated. Homer corrected a proof of this etching.[7] At a later date Homer made his own etched version, changing details and going back to the painting that had originated the watercolor. A similar situation can be witnessed in his rethinking of the impressive and grim watercolor, *Perils of the Sea* (cat. nos. 30 and 44), into the etching medium. The composition has been tightened and simplified; Homer has successfully moved from a work in watercolor to an etching which records a dramatic situation with the tonal resources prevalent in western art since Rembrandt. Homer's last etching is *Fly Fishing, Saranac Lake* (cat. no. 47), published in 1889. In it he made use of aquatint for the first time, and it is regrettable that he had not used it before and was never to use it again.

The Institute's collection possesses a most important Homer print, a work in which Homer wrestled with the difficulties of translating *Undertow*, the famous painting today in the Institute's collection.

This print (cat. no. 41) is known in only two surviving proofs, one of which has been out of sight for many years. The proof in this collection was acquired from the niece of the artist, Mrs. Doris Homer Cluney. In simplifying his composition Homer eliminated the lifeguards, and this has resulted in a loss of dramatic impact, making the work difficult to interpret. It is a pity that Homer did not find a solution to the problem, as the print is technically quite a departure from all his other works and is more painterly than any other etching from his hand. A restrike in the collection shows still another attempt to cope with the problems posed by *Undertow*. These works are considerably smaller than Homer's other etchings, with the exception of his first essay in the medium. It is possible that he felt uncomfortable in the small format and needed a huge plate.

The public did not buy the etchings, possibly because Klackner had been selling the photogravures after at least one of them as well as photogravure reproductions of paintings (this common nineteenth-century approach made the fortune of Goupil). The public at large seemed indifferent to the significant direct role of the artist in the production of etchings, unlike the more common wood engravings. The etchings were not designed for a mass market, and their subject matter in many cases came across as depressing or troubling. As Goodrich says, Homer never purged his art of nonartistic elements.[8] Although this prosaic and unadorned objectivity was precisely what Henry James, in his memorable article for the *Galaxy,* had valued in Homer, collectors in the 1880s sought a different kind of local color: compositions of a more pleasing quality and effects of tone and mood that Homer's quest for authenticity had left behind.

The last printed works with which Homer had direct relation are the two single-sheet chromos after two of his watercolors that were published by Louis Prang in the early nineties. Homer is on record as having examined proofs (similar to the one on view; cat. no. 52) of *The North Woods* and *The Eastern Shore* and imparted his approval of them. In a letter to Prang he described them as perfect.[9]

When one studies Homer's works in the field of printmaking, there is regret that the great development and flowering of his art during the 1890s is not reflected in his etchings or lithographs. Lithography, especially, which had made such great strides since Homer's apprenticeship at Bufford's workshop in the fifties, would have enabled him to strive after the bold effects and impressive chromatic subtleties that were impossible before the advent of what has been called "the color revolution."

In a letter of 1902 quoted by Goodrich, Homer said about his recent watercolors that they were "as good work, with the exception of one or two etchings, as I ever did."[10] Nothing is known about which etchings the artist had in mind, but it is quite probable that one of them was *Eight Bells* (cat. no. 42).[11] It lacks the romantic quality of Moran or the nuances of Whistler, but it shows full mastery and command of the resources at hand.

Homer's genius shines through his work, but he was not innovative or daring as a printmaker and belonged undoubtedly to an earlier tradition. Perhaps Winslow Homer as printmaker can be compared to Mary Cassatt, another American printmaker working in Paris at the same time. She, a more accomplished etcher, found in etching a channel for her creativity; unlike Homer she was moving forward and innovating and experimenting. Homer chose another path, distrusting the impressionistic qualities of artists such as Whistler, for whose "symphonies and queer things" he had no regard.[12] Homer's prints are remarkable for their objectivity and honesty. On occasion, as in *Eight Bells,* his second and possibly his best etching, there is considerable subtlety achieved with great effort and deliberation.

It has taken practically one hundred years to assess Homer's importance in the context of American printmaking. Unappreciated in his day, Homer abandoned printmaking after 1889 and concentrated on those aspects of his work that brought him financial success. Today his oeuvre as an etcher and the impressive number of wood engravings done from his drawings and designs rank among the most important contributions by an American artist in the nineteenth century.

1. Albert Ten Eyck Gardner, ed., "Introduction" to *Winslow Homer: A Retrospective Exhibition* (Washington: National Gallery of Art, catalogue for exhibition November 23, 1958-January 4, 1959), p. 76.

2. Lloyd Goodrich, *The Graphic Art of Winslow Homer* (New York: The Museum of Graphic Art, 1968).

3. Lloyd Goodrich, *Winslow Homer* (New York: Macmillan Co., 1944), p. 97 (hereafter cited as 1944).

4. Goodrich, 1944, pp. 97ff.

5. Goodrich, 1944, p. 99, and David Tatham, *Winslow Homer in the 1880s* (Syracuse: Everson Museum of Art, catalogue for exhibition December 9, 1983-January 29, 1984), p. 21.

6. Goodrich, 1944, p. 99.

7. Tatham, *Winslow Homer in the 1880s,* pp. 21, 24.

8. Goodrich, 1944, p. 204.

9. Sinclair H. Hitchings, "'Fine Art Lithorgraphy' in Boston: Craftsmanship in Color, 1840-1900," from *Art & Commerce: American Prints of the Nineteenth Century,* Proceedings of a Conference held in Boston May 8-10, 1975 (Boston: Museum of Fine Arts, 1978) p. 124.

10. Goodrich, 1944, p. 100.

11. Goodrich, 1944, p. 212, reprints the recollections of John W. Beatty; it is on the basis of Homer's having produced two proofs of *Eight Bells* for Beatty's perusal that I venture to guess that Homer was especially fond of and pleased by *Eight Bells.*

12. Goodrich, 1944, p. 213.

1836	Born February 24, in Boston, Massachusetts.
1854–55	Apprenticed to J. H. Bufford, lithographer in Boston.
1856	First illustrations published in "Proceedings at the Reception and Dinner in Honor of George Peabody"; the following year begins free-lance illustrations, including sheet-music covers.
1859	Moves to New York City which remained his winter residence until the 1880s. Supports himself largely with illustrations to be engraved for magazines such as *Harper's Weekly*.
1860	First oil paintings exhibited at the National Academy of Design, New York.
1861–63	Intermittent periods spent in Virginia with the Army of the Potomac; wood engravings of Civil War subjects published in *Harper's Weekly*.
1866–67	First trip to Paris, where two of his paintings were included in the American section of the Universal Exposition.
1868–69	Summers in the White Mountains. *Bridle Path* (cat. no. 10).
1870	First summer hunting trip to the Adirondacks.
1872	*Farmyard Scene* (cat. no. 16); *"Snap the Whip"* (two versions: Butler Institute of American Art, Youngstown, Ohio, and the Metropolitan Museum of Art, New York).
1873	Summer in Gloucester, Massachusetts; paints first watercolors.
1874	Second visit to the Adirondacks; this visit and six subsequent trips between 1889 and 1908 provide much material for watercolor compositions. *Hunting for Eggs* (cat. no. 22); *Summer* (cat. no. 23).
1875	First exhibitions of watercolors and drawings at the Brooklyn Art Association and the American Watercolor Society, New York. Last illustrations for *Harper's Weekly*. *Two Guides* (cat. no. 24).
1876	*Woman Peeling a Lemon* (cat. no. 25); *Breezing Up* (National Gallery of Art, Washington, D.C.).
1878	Summer at Houghton Farm, Hurley, New York. *Shepherdess of Houghton Farm* (cat. no. 26); *Feeding Time* (cat. no. 27).
1881–82	Trip to England; especially notable are large watercolors from Cullercoats, near Tynemouth. *Beach Scene, Cullercoats* (cat. no. 29); *Perils of the Sea* (cat. no. 30); *Fishergirl with Net* (cat. no. 31).
1883	Moves permanent home from New York to Prout's Neck, Maine. Often spends winters in southern areas such as the Bahamas, Florida, or Cuba. Begins drawing studies for *Undertow* (cat. nos. 34–40).
1884	*The Life Line* (Philadelphia Museum of Art).
1885	*Fog Warning* (Boston Museum of Fine Arts). Acquired by the MFA in 1894, this was Homer's first major work to enter a public collection.
1886	Final oil version of *Undertow* (cat. no. 40) is completed. *Eight Bells* (Phillips Academy, Andover, Massachusetts).
1889	*October Day* (cat. no. 45).
1893	Visits Columbian Exposition, Chicago. A comprehensive selection of fifteen oil paintings is exhibited. *A Great Gale* (Worcester Art Museum) wins a gold medal.
1895	*A Good Pool, Saguenay River* (cat. no. 50).
1896	*Sunset, Saco Bay* (cat. no. 51).
1900	*Summer Night* (Musée du Louvre) shown at Paris Exposition, is awarded a gold medal and is purchased for the Musée du Luxembourg (now part of the Louvre). *West Point, Prout's Neck* (cat. no. 55); *Fish and Butterflies* (cat. no. 53).
1902	*Osprey's Nest* (cat. no. 56).
1904	*Summer Squall* (cat. no. 57).
1906	Long illness in the summer; no new work 1905–08.
1908	Homer suffers a paralytic stroke.
1909	*Left and Right* (National Gallery of Art, Washington, D.C.), last major work.
1910	Homer dies at Prout's Neck on September 29.

Facing: FISHERGIRL WITH NET
(detail of cat. no. 31)

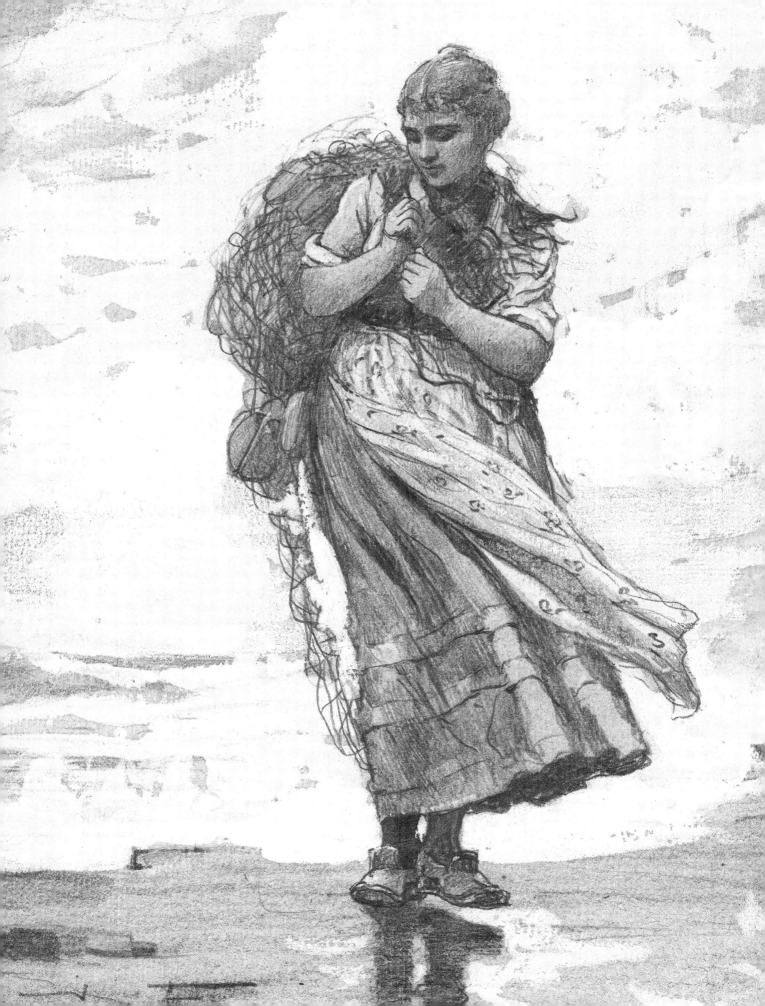

1. NEAR THE BROKEN STILE
1857
Lithograph on paper
(sheet music cover)
13½ x 10½ in. (343 x 267 mm.)
Inscribed in the stone, lower
left: W.H.
Lithographed by J.H. Bufford
Lithographic Co., Boston;
published by Oliver Ditson and
Co., 1857
No. 4403

The decorously courting couple on this music sheet are typical of the sentimental illustrations popular throughout this country as well as Europe at the middle of the nineteenth century. Homer began his professional career with works such as this while an apprentice in one of the country's foremost lithographic firms, J.H. Bufford in Boston, where he produced a composite portrait of members of the Massachusetts State Senate as well as illustrations for sheet music. Homer based his design for *Near the Broken Stile* on the cover of the English version of this song, providing American costumes for the couple and altering the background.

Originality was not a particularly prized attribute in such ephemeral publishing projects, and much of Homer's work at Bufford's entailed copying or reworking photographs or another artist's designs. In a city without a major art academy, commercial printmaking provided one of the few opportunities for a would-be artist to learn his craft while supporting himself, and Homer joined a lengthy list of American painters who had followed a similar path.

A.M.

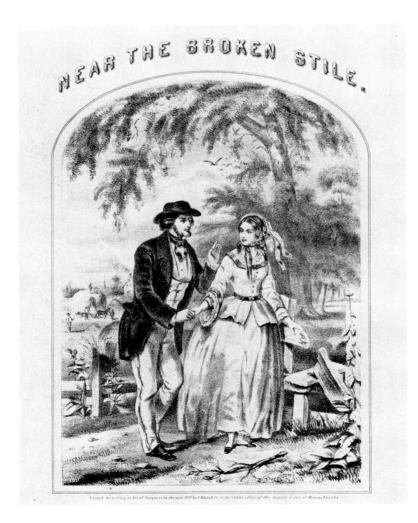

Fashionably dressed young women, engaging in the popular entertainments of the day, became a specialty for Homer as he established himself as a highly successful independent illustrator during the years preceding the Civil War. His drawings might enliven a timely article or provide an independent visual comment on modern life. Details of costume and custom were as carefully, often humorously, noted in *Skating on the Ladies' Skating Pond* as they had been in the seventeenth-century Dutch skating scenes which the drawing recalls. The accompanying text informed readers unfamiliar with New York ways that the Ladies' Pond allowed skating only by those gentlemen accompanied, and presumably slowed, by a woman; all other men were restricted to a second Central Park area, where they might skate as aggressively as they wished.

Harper's Weekly began publication in 1857, the same year Homer left the Bufford firm to become a free-lance illustrator. Its quality illustrations and timely articles by internationally famous writers helped build one of the highest circulation rates ever known by an American magazine. For nearly two decades *Harper's* would provide a ready outlet for virtually any illustrations Homer cared to submit.

A.M.

2. SKATING ON THE LADIES' SKATING POND IN THE CENTRAL PARK, NEW YORK
1860
Wood engraving after Homer
14 x 20⅛ in. (355 x 510 mm.)
Harper's Weekly,
January 28, 1860
Inscribed in the block,
lower left: WHOMER *Del.*
No. 4338

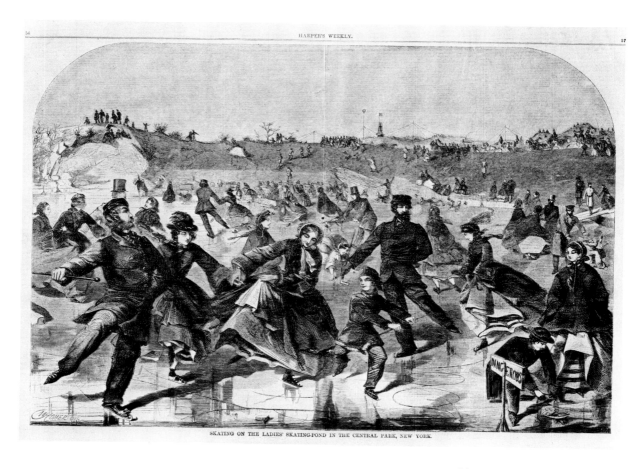

SKATING ON THE LADIES' SKATING-POND IN THE CENTRAL PARK, NEW YORK.

3. The War for the Union
1862—A Cavalry
Charge
1862
Wood engraving after Homer
13⅝ x 20½ in. (345 x 520 mm.)
Harper's Weekly,
July 5, 1862
Inscribed in the block,
lower left: HOMER *Del.*
No. 4346

Homer's chaotic scene of Union cavalry attacking Confederate troops derives directly from long centuries of battle pictures, notably the oft-engraved images of Napoleonic victories by Gros or Vernet. Homer's composition is tightly organized and densely packed with men and horses. The repeated shapes of flailing swords and kicking hooves blend together to manipulate the viewer's eye through the churning scene, in which neither side is distinctly identified. There is no sense of specific place or individual action celebrated in this, Homer's most violent and animated view of the War between the States, and although the artist avoids gruesome details or horrible scenes of death, the drawing's ultimate confusion could stand to represent any and perhaps all such futile confrontations.

Homer, and undoubtedly his editors as well, seemed to prefer to view the war in calmer images of camp life—soldiers gathered around their tents, awaiting action or news from home, or engaged in daily drudgery or nervous holiday revelry.

J.A.G.

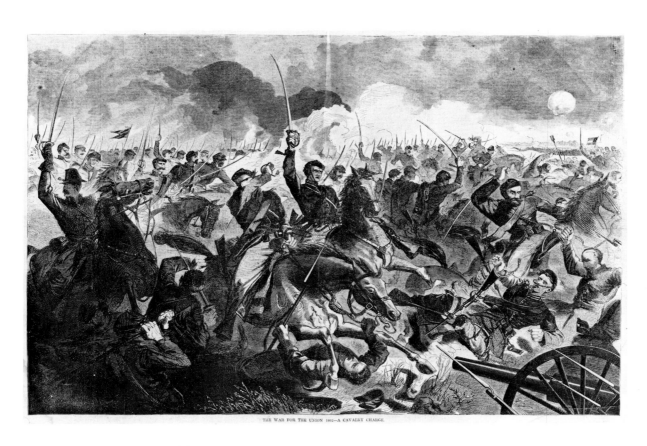

THE WAR FOR THE UNION 1862—A CAVALRY CHARGE.

The unusual vantage point, which suggests that the viewer is perched in an adjoining tree, the simple and concentrated design, the shallow spatial depth, and the strong sense of pattern make *A Sharp-shooter on Picket Duty* one of Homer's most justly famous wood engravings. It is a powerful image concentrating the deadly reality of the American Civil War in a single figure. Homer traveled to the front several times as an illustrator for *Harper's Weekly,* collecting images and sketches. The *Sharp-shooter,* published late in 1862, was based on his first significant work in oil, a medium which he began to explore professionally during the war years.

Seen at extremely close range, this striking figure is noticeably different from Homer's other, more traditional depictions of the war, and scholars have argued that the engraving's sophistication indicates a familiarity with Japanese woodblock prints. In 1862 such an interest on Homer's part would certainly have been precocious and is very difficult to demonstrate, as Japanese prints had just begun to circulate in the West after the opening of Japan in 1854. But having trained as a lithographer by studying and copying other graphic work, Homer was undoubtedly sensitive to inventive design. The characteristic elements of Japanese print composition accorded easily with his own interest in larger, more monumental figures and more forceful organization.

The realistic details utilized by Homer to characterize this specific type of soldier demonstrate his commitment to keen observation: the gun, a "match rifle," is equipped with a telescopic sight, and to enable himself to get closer to the gun sight the sharp-shooter has trimmed the visor of his cap.

J.A.G.

4. THE ARMY OF THE POTOMAC—A SHARP-SHOOTER ON PICKET DUTY
1862
Wood engraving after Homer
9¼ x 13¾ in. (235 x 350 mm.)
Harper's Weekly,
November 15, 1862
*Inscribed in the block,
lower right: Homer*
No. 1473

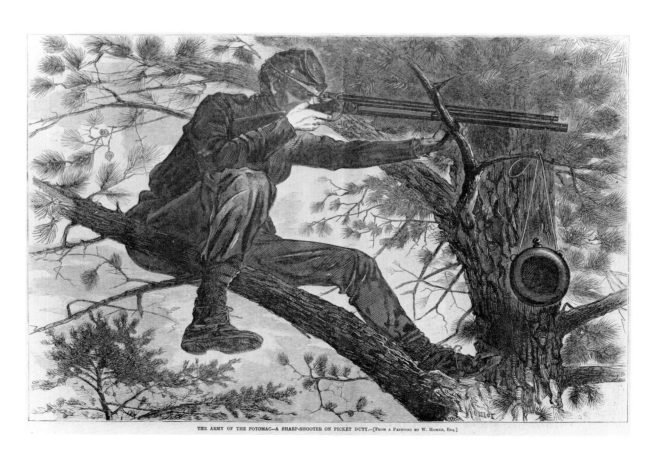

THE ARMY OF THE POTOMAC—A SHARP-SHOOTER ON PICKET DUTY.—[From a Painting by W. Homer, Esq.]

5. THE GREAT RUSSIAN BALL
 AT THE ACADEMY OF MUSIC,
 NOVEMBER 5, 1863
1863
Wood engraving after Homer
13⅛ x 20¼ in. (335 x 515 mm.)
Harper's Weekly,
November 21, 1863
Inscribed in the block,
lower right: HOMER
No. 4348

With an artificially empty foreground, Homer isolated a sequence of waltzing couples, adapting their positions and the women's swinging skirts, as well as the arcing line of the overhanging balconies, to create a visual metaphor for the swirling movement that would carry them around the immense and crowded dance floor. Although miles away the War still raged, New York social life in 1863 continued with nearly all its elegance intact, and Homer's record of the gala ball that welcomed the Russian fleet was probably a specific commission from his editors at *Harper's*.

A.M.

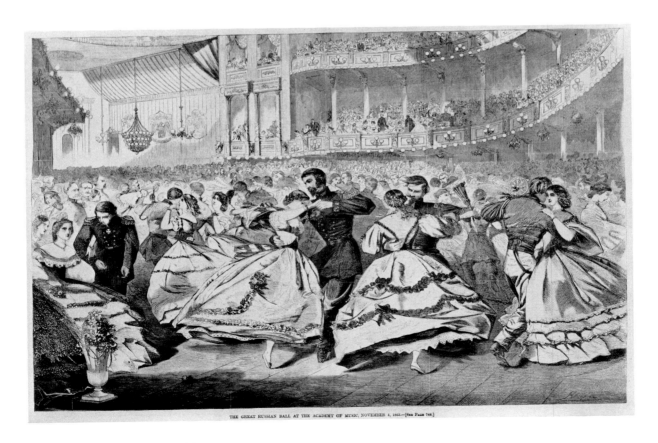

THE GREAT RUSSIAN BALL AT THE ACADEMY OF MUSIC, NOVEMBER 5, 1863.—[SEE PAGE 748.]

Beginning with his Civil War illustrations, Homer's figures had become larger, his compositions more focused and simplified. In *Our National Winter Exercise,* the two groups of skaters are spread horizontally across the picture space, with the patterns and folds of the women's hoop skirts emphasizing their flat silhouettes. The ribbons and veils that flutter across the sky reinforce the very low relief of the composition. Such space-negating devices, as well as Homer's careful overlapping of the quite different textures of the foreground skaters' dresses, argue for a significant Japanese influence on Homer's style. His initial access to Japanese woodblock prints may have come through acquaintance with the American painter John La Farge, a serious Japanophile married to the grandniece of Commodore Perry, whose fleet opened Japan to the West in 1854.

Skating scenes had appeared among Homer's earliest free-lance illustrations for the Boston periodical *Ballou's Pictorial Drawing Room Companion* in the late 1850s, and the subject would continue to intrigue him until the last years of his illustrating career (see also cat. nos. 2 and 15). They provided a seasonal illustration suitable for any winter issue of a magazine, as well as an opportunity for Homer to feature elaborate contemporary dress above a discreet glimpse of ankle.

A.M.

6. OUR NATIONAL WINTER
EXERCISE—SKATING
1866
Wood engraving after Homer
14 x 20¼ in. (355 x 515 mm.)
Frank Leslie's Illustrated
Newspaper,
January 13, 1866
No. 4617

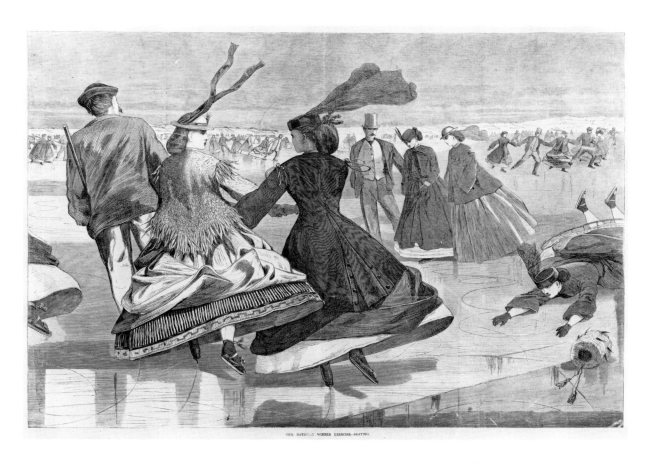

OUR NATIONAL WINTER EXERCISE—SKATING.

7. A PARISIAN BALL—
DANCING AT THE CASINO
1867
Wood engraving after Homer
9⅛ x 13¾ in. (232 x 349 mm.)
Harper's Weekly,
November 23, 1867
Inscribed in the block,
lower right: W.H.
No. 4454

During 1866 and 1867, coinciding with the great International Exposition at which two of his paintings were exhibited, Homer spent nearly a year in Paris, the nineteenth century's great mecca for artists and art students alike. Aside from an illustration of student copyists working in the galleries of the Louvre, he left little indication of what he saw or studied during his visit; but from a pair of dance illustrations published by *Harper's* we can assume that he toured the most up-to-date social attractions that the capital offered. *A Parisian Ball—Dancing at the Mabille* features the high-stepping and quite risqué *can-can*, while *Dancing at the Casino* presents an unusually lanky young beau literally sweeping his partner off her feet before a quizzical audience of top-hatted gentlemen and foreign visitors.

A.M.

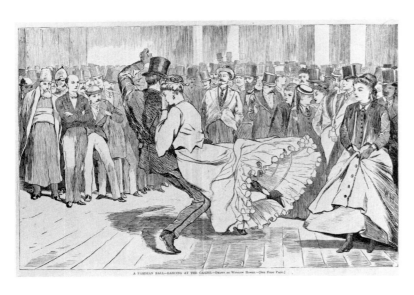

A PARISIAN BALL—DANCING AT THE CASINO.—Drawn by Winslow Homer.—[See First Page.]

9. FIRE-WORKS ON THE NIGHT
OF THE FOURTH OF JULY
1868
Wood engraving after Homer
9¼ x 13¾ in. (235 x 350 mm.)
Harper's Weekly,
July 11, 1868
Inscribed in the block,
lower right: W.H.
No. 4467

Although the subject of *Fire-works* is distinctly American, the composition, focused on a sea of expressive faces rather than the spectacle implied by the title, is decidedly French. Physiognomy and facial type-casting were trademarks of French caricature in the nineteenth century, and this work probably reflects Homer's recent exposure to contemporary Parisian illustration. Notable among the largely male crowd is the group of young women in the foreground, whose particular features and hair styles identify them as "Homer girls" as distinctly as an upswept hair roll and languid eyes would later in the century denote a "Gibson girl."

A.M.

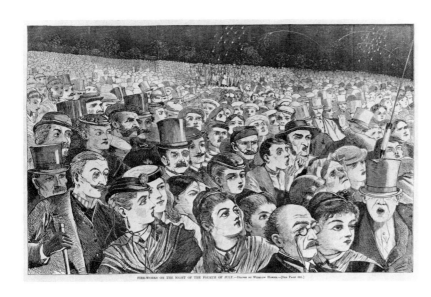

FIRE-WORKS ON THE NIGHT OF THE FOURTH OF JULY.—Drawn by Winslow Homer.—[See Page 441.]

The voyage home from Paris prompted one of Homer's most distinctive illustrations, a view of the sea-tilted deck of an ocean steamer, with young couples strolling beneath the dramatically angled beam of an empty mast. The lines of rigging, tilted masts, and planking create a deep funnel of space, offset by Homer's clever positioning of a background figure within the calipers of a woman's streaming hat ribbons in the foreground. The viewer seems to take his own place on the rolling deck, thanks to the device of two figures abruptly cut off by the edge of the print.

A.M.

8. HOMEWARD-BOUND
1867
Wood engraving after Homer
13¾ x 20½ in. (350 x 520 mm.)
Harper's Weekly,
December 21, 1867
Inscribed in the block,
upper right: W.H.
No. 4350

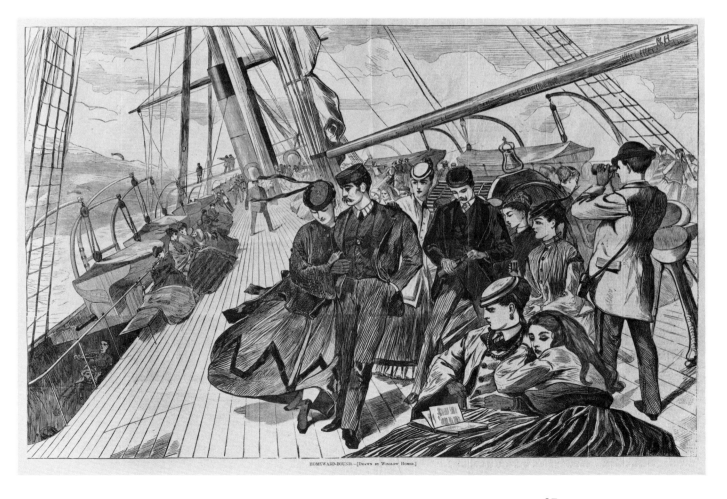

HOMEWARD-BOUND.—[Drawn by Winslow Homer.]

10. BRIDLE PATH, WHITE
 MOUNTAINS
 1868
 Oil on canvas
 24⅛ x 38 in. (61.3 x 96.5 cm.)
 Signed, lower left:
 Homer N.A./-1868-
 No. 2

An active outdoorsman himself, Homer regularly fled the heat and dust of New York City during the summer months, choosing as a retreat in 1868 and 1869—undoubtedly with an eye for suitable subject matter for his art as well as a healthful environment—the White Mountains of New Hampshire. Although obviously related by the repetition of the central horsewoman, these two views of young tourists exploring the newly fashionable Crawford Trail on Mount Washington demonstrate the growing divergence between Homer's successful graphic art and his new-found commitment to painting in oil.

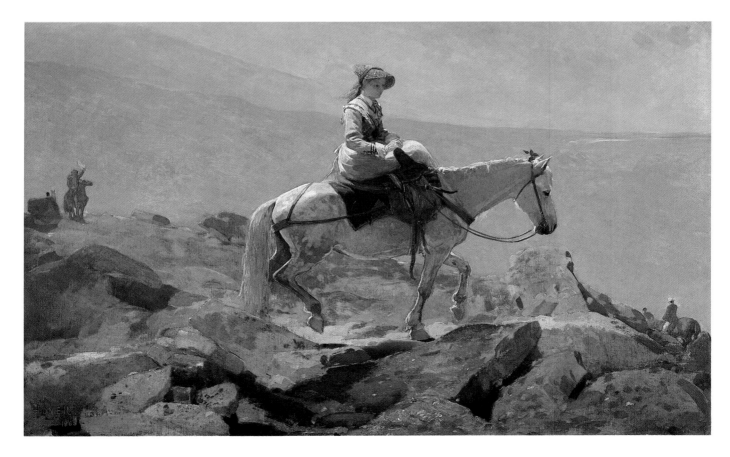

His illustration for *Harper's,* intended for a far-flung, curious audience, fully utilizes the precision of the engraving medium to emphasize descriptive details of the jaunt—the line of the mountain summit and the lodge at its peak, the trail ponies that might be hired further down the slope, and the distinct line of cloud cover through which the intrepid visitors passed to glimpse the magnificent valleys below. Hikers in decreasing size convey a sense of scale and distance, while the foreground figures appear to discuss alternative routes of ascent.

Homer's oil painting, on the other hand, executed a year before the engraving, subordinates such details to the manipulation of light and atmosphere, eliminating characteristics that would identify the site. The pensive young woman seems quite detached from the spectacle before her, and the painting becomes a study in the contrast between her solid, backlit form and the misty, color-laden haze through which she rides, a much subtler form of travelogue for Mount Washington.

Bridle Path was Homer's first new painting to be exhibited after his election to the National Academy, hence the careful annotation *N. A.* following his signature.

A.M.

11. THE SUMMIT OF MOUNT WASHINGTON
1869
Wood engraving after Homer
9 x 13¾ in. (229 x 349 mm.)
Harper's Weekly,
July 10, 1869
Inscribed in the block,
lower right: WH
No. 1480

THE SUMMIT OF MOUNT WASHINGTON.—Drawn by Winslow Homer.—[See Page 446.]

12. WINTER AT SEA—TAKING
IN SAIL OFF THE COAST
1869
Wood engraving after Homer
9¼ x 13¾ in. (235 x 350 mm.)
Harper's Weekly,
January 16, 1869
Inscribed in the block,
lower right: Homer
No. 4473

The sea, and the perils inherent in man's relationship to it, would become one of the principle themes in Homer's art during the 1880s; in this early use of such imagery, *Winter at Sea* provides a dramatic counterpoint to the seasonal illustrations Homer usually devoted to beautiful young women.

Despite the distinctly Western subject matter, the engraving is probably one of Homer's most 'Japanese' illustrations, recalling with its exceptional composition the dramatically foreshortened spaces of Hokusai in which carpenters or barrel-makers often perch precariously above a roiling sea or distant view of Mount Fuji. Even the use of oversize snowflakes against a dark sky (where the points of

light suggest stars as well) has its origin, in the days before the international triumph of Impressionism, in Japanese prints. Although it is difficult to demonstrate that Homer might have adapted Japanese conventions for handling space, complex costumes, and patterns of composition earlier in his career (see cat. no. 4), the International Exposition of 1867 firmly launched the taste for things Japanese, and even the most recent woodblock prints began to circulate widely in this country and in Europe, influencing the decorative arts and painting as well as printmaking.

A.M.

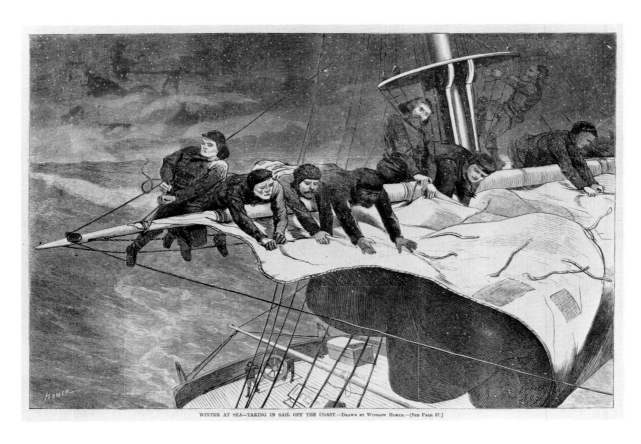

WINTER AT SEA—TAKING IN SAIL OFF THE COAST.—DRAWN BY WINSLOW HOMER.—[SEE PAGE 37.]

One of the most spacious and light-filled of Homer's drawings intended for the engraving medium, *The Artist in the Country* records the increasingly frequent sight of an artist diligently working *en plein air,* or out-of-doors. The years following the Civil War saw a widespread American interest in the landscape and natural beauties of the nation—the reaction of a rapidly industrializing civilization losing the immediacy of nature. Writers discoursed at length about the glories of American scenery; vast tourist industries took advantage of growing wealth and leisure to promote the virtues of mountain resorts and forest retreats; and the sunshade of the landscape painter, amateur as well as professional, became a ubiquitous trademark for natural beauty. Not least among these promoters of the American landscape in the next two decades would be Winslow Homer himself; this combination of distant mountain slopes with carefully detailed foreground foliage looks forward to one of the artist's best landscape paintings, *Two Guides* (cat. no. 24).

A.M.

13. THE ARTIST IN THE COUNTRY
1869
Wood engraving after Homer
6¼ x 6¾ in. (160 x 170 mm.)
Appleton's Journal,
June 19, 1869
Inscribed in the block,
lower left: J. Karst [engraver]
No. 4477

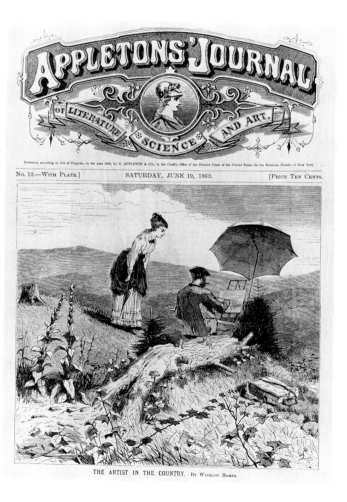

THE ARTIST IN THE COUNTRY. By Winslow Homer.

14. THE BEACH AT
 LONG BRANCH
 1869
 Wood engraving after Homer
 13 x 19⅝ in. (330 x 500 mm.)
 Art Supplement to
 Appleton's Journal,
 August 21, 1869
 Inscribed in the block,
 bottom center: WH.;
 lower left: John Karst SC.
 [engraver]
 No. 4352

This distinctive impression from *Appleton's Journal,* signed by the engraver, John Karst (as well as identified by Homer's initials traced in the sand), reveals a softness in the treatment of feminine features and flowing hair and costume quite different from the execution of contemporary Homer illustrations (such as *The Summit of Mount Washington,* cat. no. 11) which appeared in *Harper's Weekly*. Although Homer is most closely associated with *Harper's,* he also sold illustrations to other magazines, and comparisons between the final prints in different journals reveal the artist's dependence on the engravers with whom he worked.

Wood engraving for magazine illustration was a commercial art form, in which accomplished artists provided detailed, finished drawings which were then speedily engraved by one or more craftsmen onto large blocks for the mass printing necessary for periodical publication. The finished engravings reproduced here, then, were in fact a collaboration between Homer and usually anonymous artisans

working for the magazines which purchased his drawings.

Homer's inventiveness and consistent expressive quality were recognized and prized from the beginning by the publications which employed him—editors frequently extolled his merits in the blurbs or articles that accompanied his illustrations—and he could usually rely on the support of highly competent engravers. Even so, the idiosyncratic trademarks of individual block cutters often enter into the interpretation of Homer's drawings, giving particular faces a caricatural quality or design elements a treatment that defied Homer's predictable intentions. Especially significant in the final differences between *The Beach at Long Branch* and other Homer illustrations were Karst's manner of cutting patterns and the inking of the plate, which produced a richer, blacker print for this designated "Art Supplement" suitable for framing by the subscriber.

A.M.

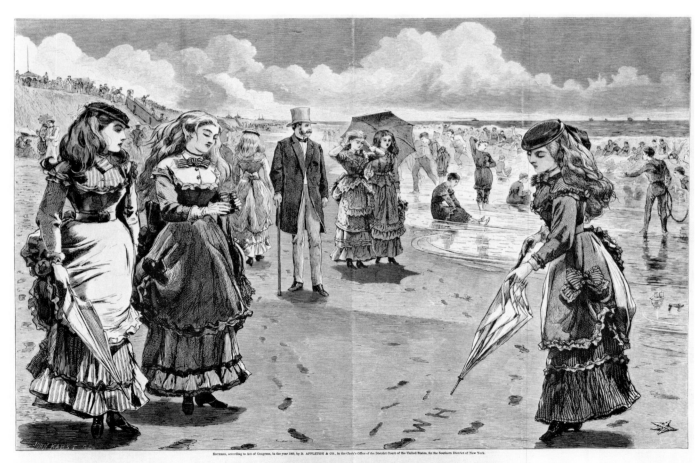

ART SUPPLEMENT TO APPLETONS' JOURNAL.—THE BEACH AT LONG BRANCH.

As the punning title suggests, *Cutting a Figure* is both a charming illustration of winter recreation and an excuse to feature an attractively dressed young woman— who in this instance looks back at the viewer directly, unlike most of Homer's more demure models. Nineteenth-century periodicals hardly differed from our contemporary versions which often depend on feminine charms to sell; and for an artist such as Homer, naturally drawn to outdoor activities and artistically sensitive to feminine beauty, such assignments do not appear to have been difficult to meet.

A.M.

15. CUTTING A FIGURE
1871
Wood engraving after Homer
11¾ x 18¾ in. (300 x 475 mm.)
Every Saturday,
February 4, 1871
Inscribed in the block,
lower left: Homer;
lower right: W. H. Morse
[engraver]
No. 4353

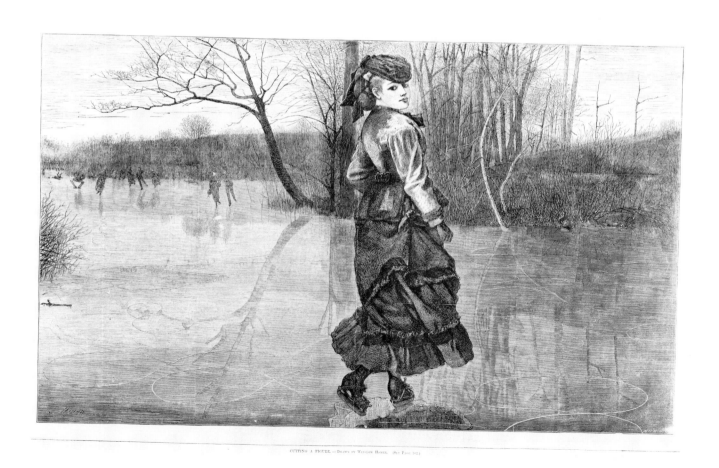

CUTTING A FIGURE. — DRAWN BY WINSLOW HOMER. (SEE PAGE 30.)

16. FARMYARD SCENE

ca. 1872
Oil on canvas
12⅜ x 18⁷/₁₆ in.
(31.5 x 46.9 cm.)
No. 772

This calm and peaceful view of a late summer afternoon appears at first glance to be a spontaneous glimpse of everyday life. A closer look reveals extremely tight organization and arrangement of the compositional elements into strong patterns. Light dictates Homer's treatment of form. The most dryly painted and detailed areas are those hit directly by the late afternoon sunlight. There is a rosy glow to the roof and chimneys of the farmhouse. Individual bricks are carefully painted and easily deciphered in the well-lit background. Shadowed areas are less precise. The birds grouped in the foreground, feeding in the shade of an apple tree, are quickly and loosely painted. Heavy fluid daubs of paint indicate their forms and the various colors of their feathers. They are simplified and abstracted as they move among the darkening shadows and lose their individual features.

Just as Homer delineated each object by the degree of light upon it, he manipulated elements to conform to an overall pattern. Consequently the chimneys of the farmhouse echo the vertical form of the young woman in the foreground. These columnar shapes are juxtaposed against the strong horizontal thrust of the house and the mass of birds in the foreground. Homer's use of rich colors further enhances the decorative quality of the picture.

The *Farmyard Scene* was painted around 1872 when Homer moved to his studio on West 10th Street. He lived in New York City for more than twenty years but rarely depicted the urban scene in his art.

Although painted when Homer was only thirty-six, *Farmyard Scene* is representative of many concerns that would become more and more important to him throughout his career. This simple composition, a young woman standing in front of a farmhouse feeding poultry, is typical of the pleasant scenes of farm and country life in which Homer freely explored the effects of strong sunlight on objects and colors.

J.A.G.

The whiteness of the chemise clinging to the beautifully realized body of a drowned woman, washed ashore still clutching the rope meant to save her, draws attention immediately in *The Wreck of the "Atlantic,"* and the dark rocks, against which a searching fisherman is outlined by a touch of moonlight, provide a stage-like setting that holds the viewer to the foreground. Only later do the floundering ship, life boats, and crowds of spectators on the rocky point far in the background complete the story. Of all Homer's illustrations in a career of nearly twenty years, *Cast up by the Sea* is the most dramatic and most powerfully conceived, and the figure is certainly among his most beautiful. The demands of large scale painting design, which began to command Homer's attention in his last years as an illustrator, clearly influenced the engraving.

While *The Wreck of the "Atlantic"* purp ts to document the destruction of a passenger steamer run aground off the Nova Scotia coast in 1873, it is now known that Homer's drawing depended on an earlier shipwreck engraving by Daniel Huntington, produced to accompany Longfellow's poem "The Wreck of the Hesperus."

A.M.

17. THE WRECK OF THE "ATLANTIC"—CAST UP BY THE SEA
1873
Wood engraving after Homer
9¼ x 13¾ in. (235 x 350 mm.)
Harper's Weekly,
April 26, 1873
Inscribed in the block,
upper left: W.H.
No. 2629

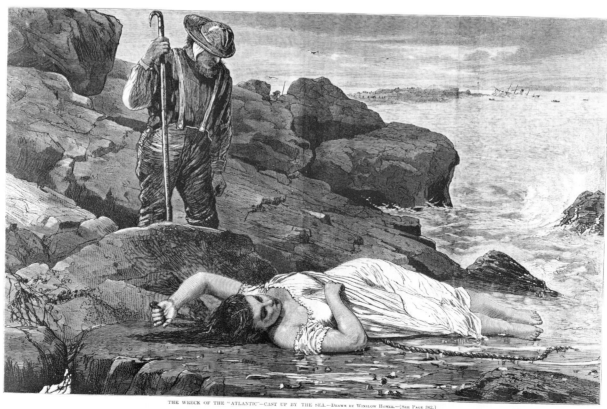

THE WRECK OF THE "ATLANTIC"—CAST UP BY THE SEA.—Drawn by Winslow Homer.—[See Page 342.]

35.

18. THE BATHERS

1873
Wood engraving after Homer
13¾ x 9¼ in. (350 x 235 mm.)
Harper's Weekly,
August 2, 1873
Inscribed in the block,
lower right: Redding SC
[engraver]
No. 4060

Many of Homer's illustrations trace the changing social mores that opened to young women a wide range of active, outdoor recreations in the years following the Civil War. Illustrations sent back from his own summer outings featured horse-women, hikers, even a pair of young women exploring the underside of a great Catskill mountain waterfall; but none of the new freedoms taken up by the young beauties of the day was so problematic as sea-bathing. As late as 1871 an article accompanying a Homer bathing illustration counseled the reluctant bather that precautions could be taken to assure there would be no outrage against the proprieties—but warned that there was less assurance the bather might not become a spectacle, the object of derision and amusement!

A.M.

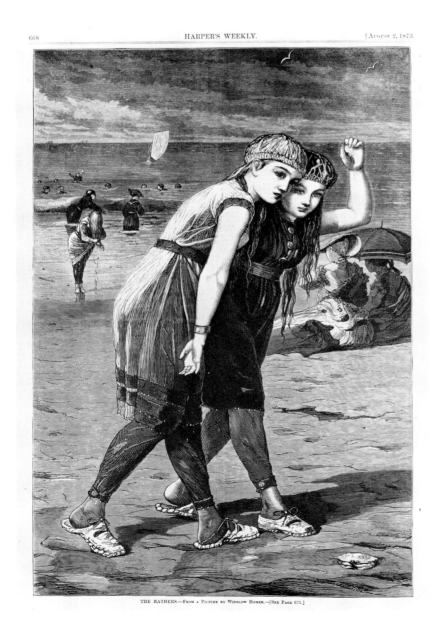

THE BATHERS.—FROM A PICTURE BY WINSLOW HOMER.—[SEE PAGE 671.]

Three versions of the ever-popular *"Snap the Whip"* exist; perhaps the most successful is this wood engraving made for *Harper's Weekly* in 1873. First composed in oils in 1872, the picture probably dates from a late spring visit to the farm town of Hurley, New York, near the Catskill Mountains. The engraving, executed a year after the painting, reveals a sharper, more detailed composition. Without making major changes Homer strengthened the design, increasing contrast, sharpening features and details, and refining overall patterns.

Homer was infatuated with childhood. He devoted many pictures to children exploring and reveling in the natural world around them. These scenes were not intended to be sentimental or nostalgic but instead are innocent, straightforward, and often—as in the case of *"Snap the Whip"*—unemotional portrayals. Homer placed children in the landscape as if they belonged to it as integrally as trees or flowers. With *"Snap the Whip"* Homer captured exuberant schoolboys just at the climax of their game. The two boys on the extreme right stop and tug the arms of their running comrades, causing the boys at the other end of the line to tumble to the ground.

J.A.G.

19. "SNAP THE WHIP"
1873
Wood engraving after Homer
13⅝ x 20⅝ in. (346 x 524 mm.)
Harper's Weekly,
September 20, 1873
Inscribed in the block,
lower left: Lagarde SC [engraver];
lower right: Homer 1873
No. 4354

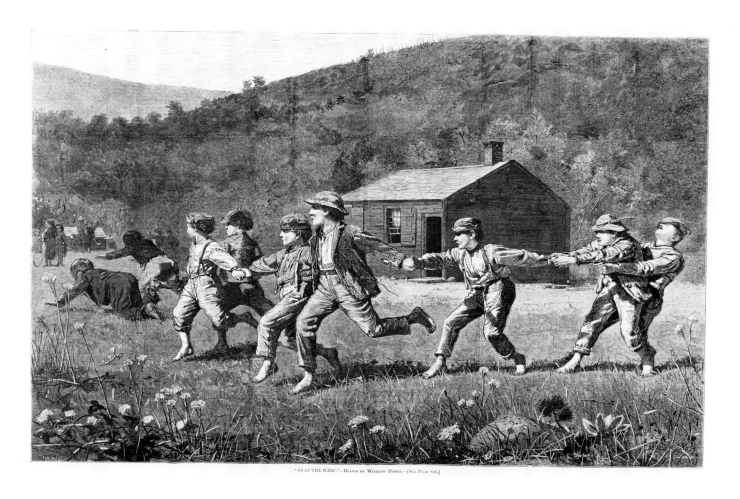

"SNAP-THE-WHIP."—Drawn by Winslow Homer.—[See Page 826.]

20. STATION-HOUSE LODGERS
1874
Wood engraving after Homer
9 x 13⅜ in. (230 x 340 mm.)
Harper's Weekly,
February 7, 1874
No. 4493

Homer's illustrations are among the best-loved images of nineteenth-century America in large measure because the artist's remarkable skill and delightful inventiveness were nearly always employed to support views of a society at its best; *Station-House Lodgers,* one of Homer's last engravings, stands virtually alone in recording a troubled underside to that society.

Across the floor of a large, featureless room, a tattered pile of vagrants spreads. The gray dimness of the interior is broken only by the light surrounding a policeman in a doorway, surveying the scene. His watchfulness is matched by a figure on the left, who rises above the crowd of bodies to gaze vacantly out of the scene.

A.M.

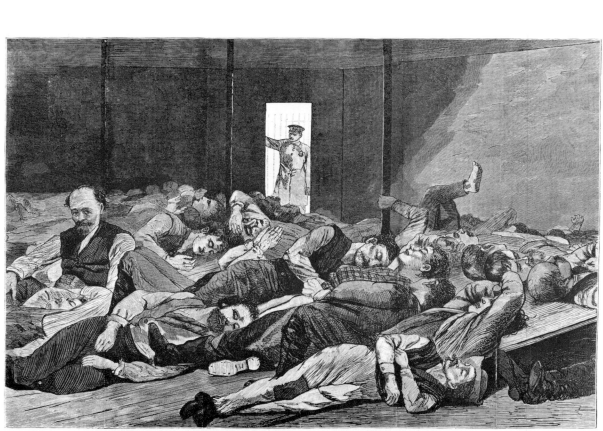

STATION-HOUSE LODGERS.—FROM A DRAWING BY WINSLOW HOMER.—[SEE PAGE 133.]

Children furnished the most frequent motifs for Homer during the 1870s as he turned his talents to paintings and drawings. Playing in the meadows and sand dunes or contributing to the family chores, they provided both novel subject matter and an effective human presence in his pictures, without the constraints of demanding adult themes, at a time when Homer was still mastering his own style. Signed and dated with the same heavy, white gouache that suggests strong sunlight across the young girl and her chair, this is not a working, preparatory study for another object—an oil painting or more finished drawing—but a few moments of observation finished up, perhaps as a gift or souvenir for a friend.

A.M.

21. CHILD SEATED IN A WICKER CHAIR
1874
Black crayon and white gouache with pencil on light gray paper
13¼ x 10 in. (335 x 254 mm.)
Signed, lower left:
HOMER 1874
No. 1487

39

22. HUNTING FOR EGGS
 1874
 Gouache over pencil on paper
 9¾ x 5½ in. (249 x 141 mm.)
 Signed, lower right:
 HOMER *1874*
 Verso, signed: Hunting for Eggs /
 Winslow Homer
 No. 1497

Summer and *Hunting for Eggs* are especially attractive examples of the small, carefully colored watercolors with which Homer began a new aspect of his art in the mid-1870s. Having begun in 1862 to supplement his work in black and white with serious study of oil painting, in 1873 he abandoned commercial illustration almost entirely to concentrate on watercolor drawings. Homer had had his first instruction in the use of the medium many years earlier from his mother, a particularly competent amateur watercolorist.

Homer's earliest watercolor style developed directly out of the linear manner of his illustrating technique: a careful drawing was fully worked out in pencil, then quite precisely colored with thick, frequently opaque watercolors (generally described as *gouache*). In both *Summer* and *Hunting for Eggs,* the pencil drawing remains visible where the watercolors are most transparent—in the white pinafore on the egg hunter or in the woman's hands and the flower pole of *Summer*. Color was then added with small, heavy touches and brushstrokes that usually

obliterate the drawing marks but preserve the precision and careful shaping of the sketch. Only in the central shadow of the striped skirt or in the geranium leaves and bit of visible petticoat does the artist exploit the fluid possibilities of the medium.

In their diminutive scale and the delicacy of their handling—as well as in the obvious appeal of their attractive subjects—*Summer* and *Hunting for Eggs* fit firmly within the late nineteenth-century taste for smaller works of innocuous subject and careful finish intended for the growing numbers of new collectors created by decades of prosperity. The renewed popularity of prints and the new American interest in watercolors to which Homer readily responded were a direct testament to a rapidly changing art world.

A.M.

23. SUMMER
1874
Gouache over pencil on paper
8⅝ x 4¾ in. (219 x 111 mm.)
Signed, lower left: WH 74
No. 1491

Two Guides is one of Homer's most successful oil paintings and marks an important point in his artistic development. With this picture he achieved a degree of stylistic maturity which is evident on many levels, from technical to philosophical. A strong and cohesive composition which appears to be almost photographic as well as atmospheric, the painting embodies Homer's lifelong preoccupation with the relationship between man and the natural world.

Painted in Keene Valley around 1875, *Two Guides* was one of Homer's earliest Adirondack oil paintings. The clear colors, luminous atmosphere, and bold design elements that characterize his watercolors are also present in *Two Guides*. The picture is tightly organized around the strong diagonals of the mountain slopes. These patterns are supported by the wispy gray clouds in the middle of the picture and the ax handle in the foreground which recedes sharply back toward the mountains. There is a distinct contrast between the highly detailed foreground and the more translucent, fluid forms of the hills beyond.

Winslow Homer first visited the Adirondacks around 1870. Together with his brother Charles he hunted, fished, and camped in the remote wilderness of northern New York. A regular visitor through the summer of 1908, Homer became familiar with the landscape, climate, animals, and characters of the North Woods.

There has been a great deal of conjecture devoted to the identities of the two guides. The older man is thought to be "Old Mountain" Phelps, a well-known and colorful Adirondack guide. Lloyd Goodrich, in his biography of Homer, quoted a contemporary description of Phelps:

He was a true citizen of the wilderness. . . . His tawny hair was long and tangled, matted now many years past the possibility of being entered by a comb. His features were small and delicate, and set in the frame of a reddish beard. . . . His clothes seemed to have been put on him once for all, like the bark of a tree, a long time ago. . . .

The younger man has been identified as Monroe Holt, the son of a settler of Keene Valley. Holt later became Justice of the Peace and Keene Town Supervisor but was equally famous for his imposing size and his vivid red shirt.

J.A.G.

24. TWO GUIDES
1875
Oil on canvas
24¼ x 38¼ in. (61.3 x 97.1 cm.)
Signed, lower left:
Winslow Homer/187(5)
No. 3

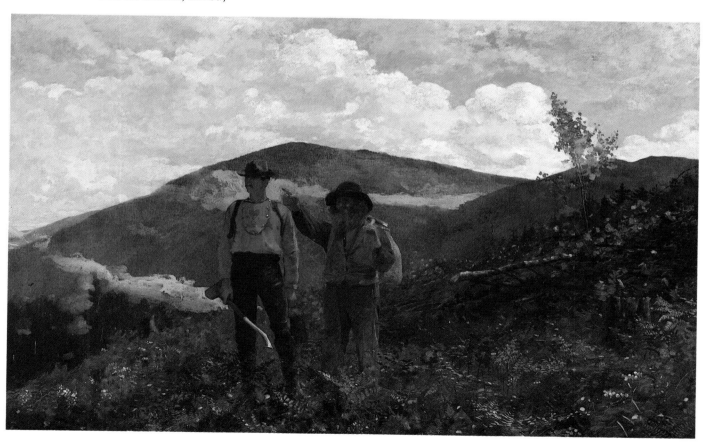

25. WOMAN PEELING A LEMON
 1876
 Watercolor over black chalk on
 paper
 18⅞ x 12 in. (480 x 303 mm.)
 Signed, lower left: HOMER '76
 No. 1494

In the two years between Homer's entrancing little watercolors, *Hunting for Eggs* and *Summer* (cat. nos. 22 and 23), and this larger sheet, *Woman Peeling a Lemon*, his skill in the new medium had increased dramatically. No longer do the paintings mimic the heavy colors and techniques of work in oil; rather Homer is now able to exploit the particular qualities of watercolor. While he still relies on the support of a chalk drawing, the figure is shaped three-dimensionally with variations in the density of watercolor itself, and with soft blue shadows on her hands and face. The subtlety in changes of hue and tone possible with watercolor has been emphasized by a severely limited palette—a range of reds and whites, with accents of dark blue and, of course, the yellow lemon. Even the shift in scale that differentiates watercolors from oils has been utilized. The background detail that established three-dimensional settings in *Summer* and *Hunting for Eggs*, and coincidentally displayed Homer's sure brushwork, has been suppressed here and replaced with a thin, fluid wash of color that complements the figure but does not distract the viewer's attention from the focus of the composition.

The redheaded young woman who posed for this watercolor appears in a large number of Homer's works during the mid-1870s (including cat. nos. 22 and 23), and efforts have been made to identify her as the great love of his life, who spurned Homer's offer of marriage.

A.M.

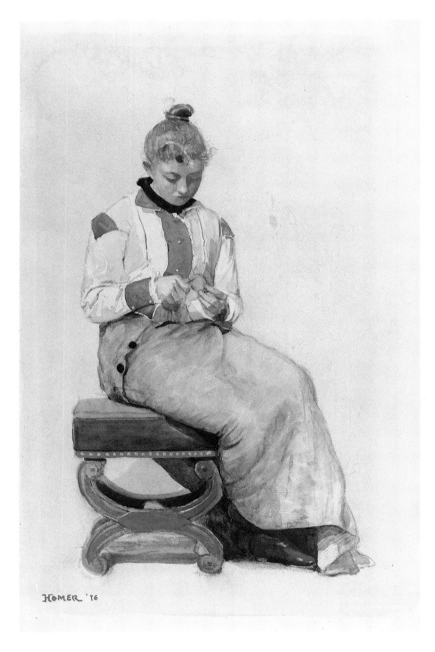

Homer's critical success at the 1879 exhibition of the American Water Color Society rested largely on the body of work he had produced the preceding summer at Houghton Farm in Mountainville, New York. The watercolors were acclaimed for their originality, even a distinct naïveté, and Homer's feeling for color and atmosphere was especially admired. With the Houghton Farm watercolors, Homer began a pattern of working in which each new location prompted such characteristic changes of style that the resultant drawings are readily grouped by locale, no matter what their specific subject matter.

The Houghton Farm watercolors such as *Shepherdess* were executed rapidly out-of-doors and challenged Homer to a new level of inventiveness and manipulation of the means at his command. Probably completed early in his stay, *Shepherdess* is noteworthy for the unusual, acidic hues which Homer favored and for its airiness and the sense of space achieved with the careful control of color divisions in the landscape. However, it does not yet demonstrate the complexity of technique that would characterize the best Houghton Farm watercolors such as *Feeding Time* (cat. no. 27).

Houghton Farm was the home of Lawson Valentine, business partner to Homer's brother Charles and a devoted patron of Homer's art.

A.M.

26. SHEPHERDESS OF HOUGHTON FARM
1878
Watercolor over pencil on white illustration board
11 x 19 in. (280 x 483 mm.)
Signed, lower right:
Winslow Homer 1878
No. 1483

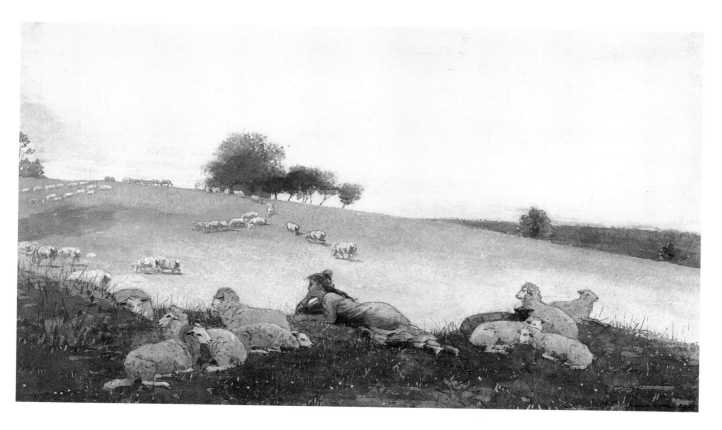

27. FEEDING TIME

probably 1878
Watercolor and gouache over
pencil on paper
8¾ x 11¼ in. (222 x 284 mm.)
Signed, lower right: HOMER
No. 1493

Although the whole composition of *Feeding Time* is luminous and touched with delicate, overlapping washes of blue, yellow, and green, there is a distinct contrast in the artist's treatment of foreground and background. As an important transitional work from Homer's summer at Houghton Farm, the watercolor marks a critical phase in his style and technique.

The foreground has been sketched in graphite with contours and outlines used as boundaries for colored washes. Graphite lines also establish folds and textures in fabrics and objects. Heavy opaque white gouache is used to highlight the backs of the cows and the fence rails. It is worth noting that Homer used this more conservative descriptive technique in the area containing the anecdotal content of the picture.

The background appears more spontaneous; loose, transparent washes and quick brushstrokes create an impressionistic blend of greens. There is no underdrawing visible in this section of the composition. Contours are muted, edges soft and blurred as they would appear from a distance. Using looser brushwork and thinner layers of wash, Homer reveled in pure light and color. He also incorporated other innovative techniques, such as blotting or lifting out wet paint to let earlier layers show through.

Feeding Time, like so much of Homer's work in watercolor in this period, looks backward to his training as a wood engraver as well as ahead, toward contemporary French preoccupation with the changing effects of light and atmosphere.

J.A.G.

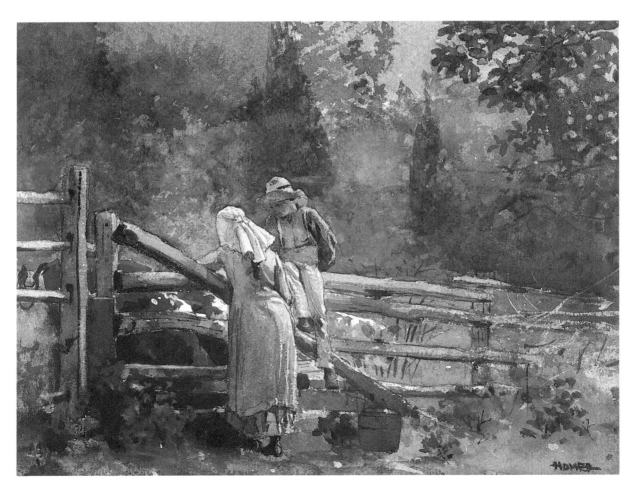

Homer has been credited with virtually inventing the "American Girl"—a type regularly encountered in his magazine illustrations and here celebrated in an independently issued heliotype. As in *Yachting Girl,* Homer's favored subjects were attractive, uninhibited young women actively taking part in all manner of outdoor activity—and they were always beautifully clothed, in elaborate dress suitable to the occasion and rendered by Homer with great attention to detail and decoration.

While Homer's magazine illustrations made his American girls well known throughout the country, they brought him only the one-time fee paid by the publishers. This heliotype, although known in only a small number of examples, was probably a first effort by Homer to profit directly from the large market for prints and reproductions.

A.M.

28. YACHTING GIRL
1880
Heliotype touched with white gouache on paper
7¾ x 12⁷/₁₆ in. (197 x 315 mm.)
Inscribed in the stone, lower left: Copyright – 1880 Winslow Homer; signed in pencil, lower left margin: Winslow Homer No. 1968.21

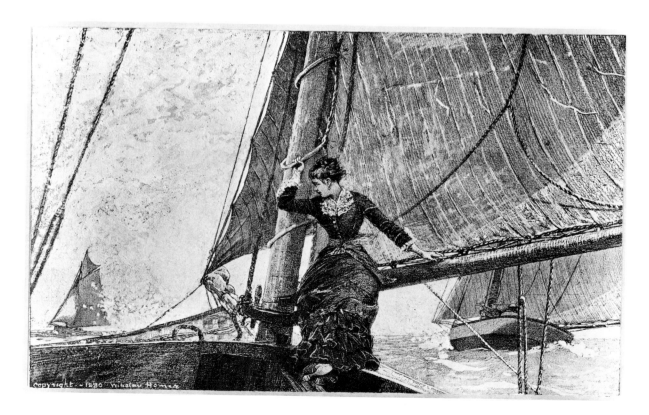

29. BEACH SCENE, CULLERCOATS
1881
Watercolor over pencil on paper
11½ x 19½ in. (291 x 496 mm.)
Signed, lower right:
Winslow Homer 1881
No. 1490
(reproduced in color on cover
[detail] and title page)

Large areas of thin, broadly-worked washes of color, balanced with foreground details in intense, bright colors, identify this *Beach Scene* with Homer's twenty-month stay in a small fishing village outside Tynemouth, England. He had traveled to Britain in 1881 largely to master English watercolor technique, and the more than 150 watercolors produced in and around Cullercoats demonstrate the full range of technical effects characteristic of earlier nineteenth-century English artists (who are credited with virtually inventing modern watercolor painting) as well as a steadily increasing command of two-dimensional design. Even more important for the future of Homer's art, however, was his new commitment to exploring the relationship of man with the sea.

The Cullercoats watercolors have an airy openness and a heightened color key that set them apart from Homer's earlier work. His ability to suggest large, deep spaces derives directly from a new facility with thin washes of color, often laid one upon another as in the sandy beach shown here, or modulated with sponging and lifting techniques as in the areas of sky around the beached boats. The broader stage which he gained with this new facility allowed him greater flexibility in activating the middle ground areas with figures and details worked in denser washes, the whole finally set off with the very bright local colors of costume and architecture in the foreground scenes. Ultimately he could tackle far more complex compositions than had been possible with the more limited technical means that characterized his Houghton Farm pictures (cat. nos. 26 and 27).

The division of labor among the Cullercoats fisherfolk was strictly sexual—the men took the boats out and fished all night; the women met the boats, divided the catch, and sold it during the day in larger towns nearby. In *Beach Scene* young girls, two with younger siblings strapped to their backs, wait with empty baskets for the return of the cobles, the distinctive fishing vessels of the region. Homer's subject matter, the daily life of the fishing village at Cullercoats, and even many of his specific themes, such as wives and children scanning the horizon for missing boats or basket-laden women crossing the flat beaches, are directly derived from the very popular art of contemporary Dutch artists known as the Hague School for the continental fishing town with which they were associated.

A.M.

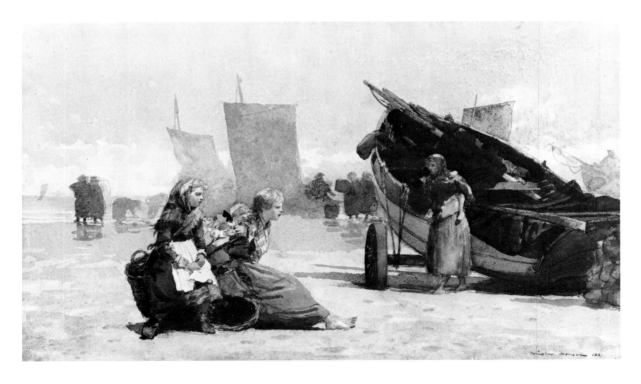

This expressive drawing combines pencil, charcoal, and white and gray washes on textured gray paper. Homer's emphasis is on mass—the sculpturesque fishergirl and thick, foamy waves and clouds around her—but he also delights in abstract, calligraphic lines that accentuate patterns repeated throughout the picture. Strong black linear angles define the surf as it splashes on the beach, and the men in the background are heavily outlined in black. Patterns echo through the composition: the standing fisherman with arm raised reflects the shape of the fishergirl who carries a net over her shoulder. The small boat with billowing sail on the left repeats the "s" curve of the fishergirl's body, created by the wind blowing through her skirts.

Unfortunately *Fishergirl with Net* has become discolored. Over time the drawing was burned by exposure to sunlight and an acid paper mat. This caused the paper to yellow, and consequently the effect of the dramatic white washes against the monumental figure of the girl is diminished.

J.A.G.

31. FISHERGIRL WITH NET
1882
Pencil heightened with white gouache with gray and white washes on gray paper
11⅜ x 16⅛ in. (289 x 489 mm.)
Signed, lower left: HOMER 82
No. 1485

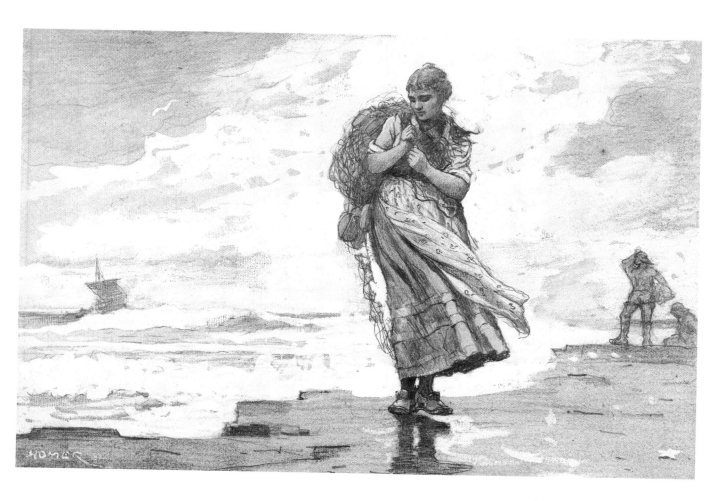

30. PERILS OF THE SEA

1881
Watercolor over black chalk
on paper
14⅝ x 21 in. (371 x 532 mm.)
Signed, lower right:
HOMER / 1881
No. 774

The dramatic tension inherent in the unseen events implied by *Perils of the Sea* underlines the profound shift in Homer's subject matter that occurred in parallel with the technical advances (see preceding entry) he achieved during his stay in Cullercoats during 1881 and 1882. Henceforth the sea and the complex ambiguities of man's relationship to its deadly beauty would be one of the most significant themes of all Homer's art.

Unlike many of Homer's watercolors which were rapidly executed out-of-doors, *Perils of the Sea* was composed in the studio from a large number of preparatory sketches showing women huddled against the railing above Cullercoats's Look-out House and anxious fishermen

scanning the waves below. Few of the studies closely resemble the final composition, for which Homer tried and rejected many combinations of figures, ultimately including elements from many sketches. In the finished painting, details are restricted to the two central female figures, who are more monumental and more isolated from the surrounding landscape than figures in Homer's earlier works. With their physical distance from the fishermen below and behind them—who are massed together and less individualized—Homer stressed the women's helplessness in the face of the raging storm.

Perils of the Sea is extremely atmospheric, the effect dark and forbidding. Within the layered washes of gray and brown, the only assertive color appears in

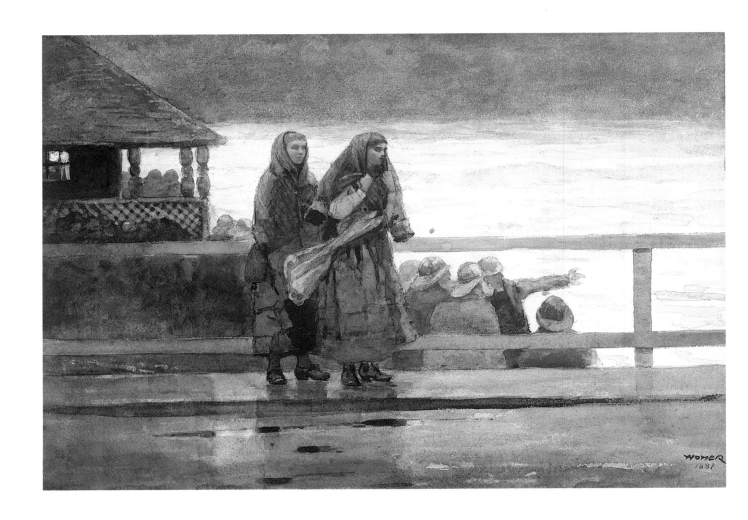

a shawl worn by one of the women. This use of a small detail of bright red, almost always a piece of clothing, to offset a nearly monochromatic color scheme, was a favorite convention Homer used throughout his career.

Homer refined his composition considerably when he decided to repeat it as an etching, eliminating some details and changing others. The railing behind the two women is gone, and the man in the background is no longer pointing out to sea. Homer has tightly organized the composition on a diagonal, massing the human element in one-half of the paper in sharp contrast with the wild, open space of sea and sky. The overall pattern is strong, as is the emotional impact of the picture. One senses the panic, fear, and vulnerability of these people who live with and depend on the sea. In taking the etching one step farther than the watercolor, Homer arrives at a very different statement. The watercolor is atmospheric—one can almost feel the damp fog rolling in—and more anecdotal, capturing a specific moment in the life of the village of Cullercoats. The print is stark, hard, and bleak, portraying more dramatically the impersonal and universal relationship of man and the sea.

Perils of the Sea has been reversed in the etching because Homer did not compensate for the natural reversing of the print process when he created the etching plate.

J.A.G.

44. PERILS OF THE SEA
1888
Etching with remarque on paper
16⅛ x 20⅞ in. (410 x 530 mm.)
Signed in the plate, lower right:
Homer; signed in pencil, lower
right margin: Winslow Homer
No. 1482

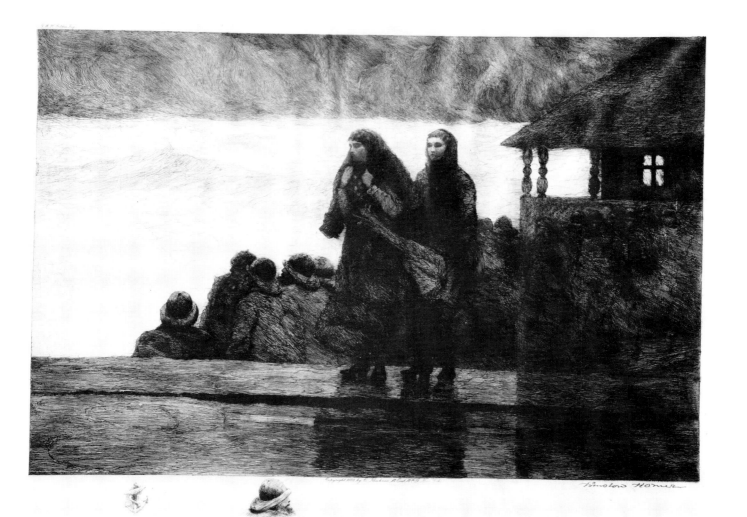

PERILS OF THE SEA

34. *Study for* UNDERTOW, I
 about 1883-86
 *Pencil and black chalk on
 green-gray paper*
 7⅛ x 8⅝ in. (182 x 219 mm.)
 Verso: Studies of Sheep
 No. 1481a

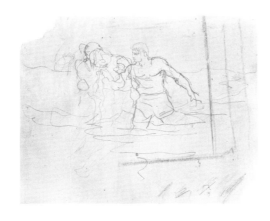

35. *Study for* UNDERTOW, II
 about 1883-86
 Pencil on paper
 5 x 7¹³⁄₁₆ in. (127 x 199 mm.)
 No. 1481b

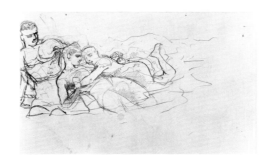

36. *Study for* UNDERTOW, III
 about 1883-86
 Pencil on pale blue paper
 5¾ x 7¼ in. (146 x 185 mm.)
 *Signed, center left: Homer;
 lower center: The Rescue;
 lower right: April 25, 1886*
 *Verso: Study of a man in a
 sou'wester cap*
 No. 1481c

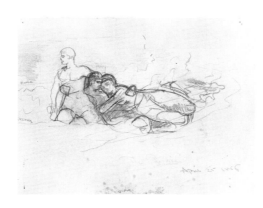

37. *Study for* UNDERTOW, IV
 about 1883-86
 Pencil and black chalk on paper
 5¾ x 8⅞ in. (146 x 226 mm.)
 Inscribed, lower right: No. 1
 Verso: Study for Undertow, VII
 No. 1481d

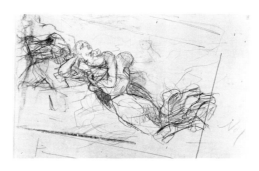

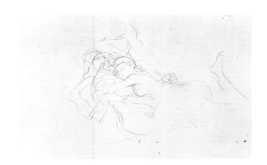

Undertow (see following page) is the
second of Homer's large and ambitious
oil paintings to address the classic themes
of life and death and man's struggle
against the forces of nature through sub-
ject matter that was decidedly contempo-
rary. Like *The Life Line* (Philadelphia
Museum of Art; see cat. no. 32), which
had won Homer his greatest acclaim two
years earlier, *Undertow* was well received
by the critics, who especially applauded
Homer's skill in presenting human
figures.

 The near-drowning of two young
women recorded in *Undertow* is said to
reflect an actual rescue which Homer
witnessed at Atlantic City during a visit
he made in 1883 specifically to study life-
saving techniques of the famed Atlantic
City Rescue Guard—when he had already
fixed on the subject of a breeches buoy
(or life line) rescue for a major painting.
The existence of a preliminary drawing
(cat. no. 34) clearly related to *Undertow*
but showing only one victim supported
between two rescuers, as well as several
drawings depicting one rescuer and two
women (cat. nos. 35, 36, 37 recto and
verso, and 39) suggests that Homer did
not in any event feel committed to a
specific set of facts as the basis of his
picture.

 The existence of so many working
drawings for the painting reflects the seri-
ousness of Homer's method in creating
Undertow. Whether or not the painting
was based on an actual event, the number
of victims and rescuers as well as their
specific grouping was an artistic decision
established in the process of creating the
final painting, not a matter of reportage.
As a self-taught artist and one whose early
career had been devoted to black and

white illustration, Homer lacked serious experience in drawing the nude, considered at least by Europeans as the single most important skill necessary for the would-be master. Nonetheless he set to work preparing the painting with studies of two bathing-suit-clad young women posed on the roof of a New York building. His difficulties in resolving the final relationship of their bodies are evident in the number of poses; and his problems in recording a chosen position are particularly apparent in cat. no. 37 verso, in which he moves in on a final outline with a series of rough, repeated pencil marks.

The final painting is strongly composed and very beautifully painted, with a looseness of handling in the waves and sky that surprisingly complements the more tightly finished figures. Homer's roof-top studies are well justified in the careful shadowing of the figures. Most striking, perhaps, is the originality of Homer's color, limited to a broad range of blues heightened only by whites, yellows, and a touch of strong red.

Even in elements in which he had artistic choice, such as the rescuer's swimming trunks or the younger girl's bathing dress, Homer maintained this narrowly defined palette, giving the painting the extraordinary blueness that suggests the pervasive flash of light off water.

A.M.

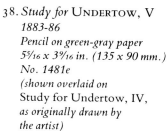
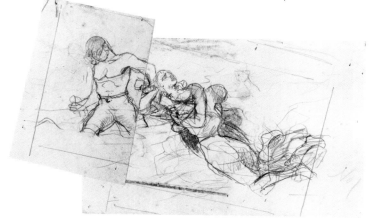

38. *Study for* UNDERTOW, V
1883-86
Pencil on green-gray paper
5�5/16 x 3⁹/16 in. (135 x 90 mm.)
No. 1481e
(shown overlaid on
Study for Undertow, IV,
as originally drawn by
the artist)

39. *Study for* UNDERTOW, VI
1883-86
Pencil on paper
5¾ x 8⅞ in. (146 x 226 mm.)
Inscribed, upper right: over;
verso: No. 2
No. 1481f

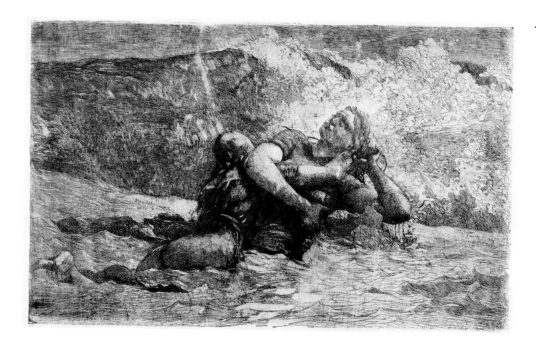

41. STUDY FOR UNDERTOW
about 1886
Etching on paper
6¾ x 10¼ in. (170 x 260 mm.)
Signed in the plate, lower left:
Homer sc.; lower right: Copyright
Winslow Homer
No. 1968.20

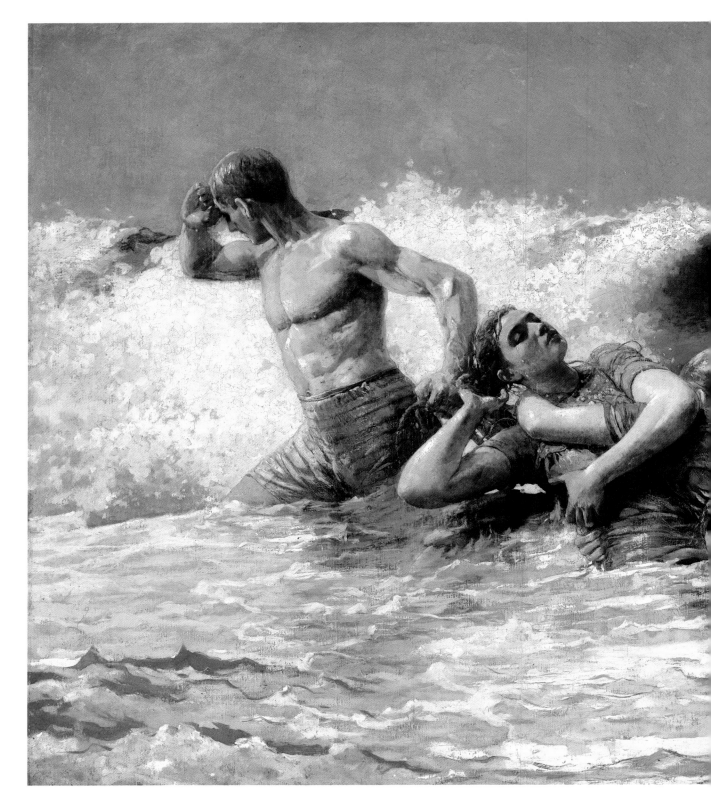

54

40. UNDERTOW
1886
Oil on canvas
29¹³/₁₆ x 47⅝ in.
(75.8 x 121.7 cm.)
Signed, lower right:
Winslow Homer / 1886
No. 4

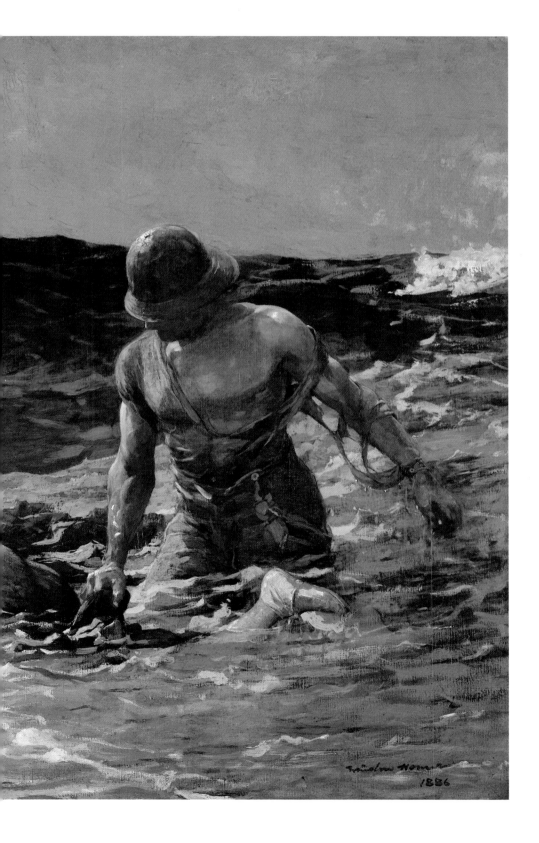

32. LIFE LINE

1884
Etching on paper
12¼ x 17½ in. (310 x 445 mm.)
Signed in the plate, lower left:
Homer 1884; lower right:
Copyright 1884 Winslow Homer
No. 1484

Life Line and *Saved* are both reworkings, in the medium of etching, of a painting that was Homer's first great popular success, also entitled *The Life Line* (Philadelphia Museum of Art) and exhibited in 1884.

An exceptionally dramatic picture, *The Life Line* purported to show an incident Homer had seen the previous summer in Atlantic City, although in fact it originated in a rescue he had witnessed in England some years before. The life line, or breeches buoy, was a pulley system invented for evacuating floundering ships close to shore. One end of the line was securely anchored on land, the other attached to the distressed ship, allowing

the rescue of crew and passengers who could not be brought ashore by lifeboat because of raging seas.

The first graphic version of the subject was undertaken by Homer immediately after completion of the painting, as prints were available for sale at the exhibition, obviously in anticipation of the picture's enthusiastic reception. It follows the painting quite closely in composition, simply eliminating suggestions of the floundering ship at upper left and the rocky shore at upper right, the anchors for the long rescue line. Homer had only begun using the etching medium the preceding year, and although the composition is clear and powerful, his technique is rather harsh and unvaried.

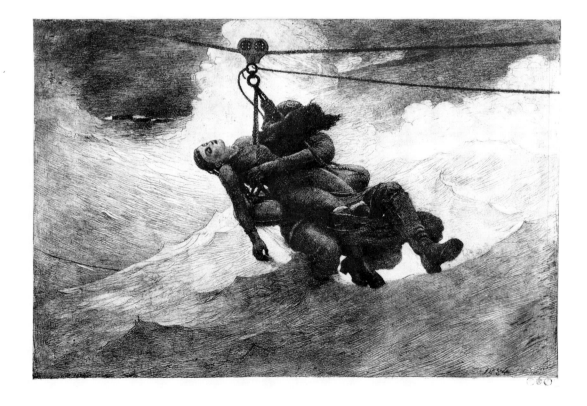

Saved, executed on a much larger scale five years later, probably in the hope of a greater commercial return, reveals Homer as a highly skilled etcher. The composition has been considerably altered by simplifying the background, thus emphasizing the pair of figures, who are now more strongly silhouetted against the sea. Homer's command of the etched line is now much finer, and his ability to realize a painterly range of shading produces a far more beautiful figure against an eloquently subtle sea.

A.M.

46. SAVED
1889
Etching on paper
16⅞ x 27¾ in. (428 x 704 mm.)
Signed in the plate, lower left:
Winslow Homer Sc; upper left
margin: G. W. H. Ritchie Imp;
upper right margin: Copyright
1889 C. Klackner, N. Y.
No. 1972.16

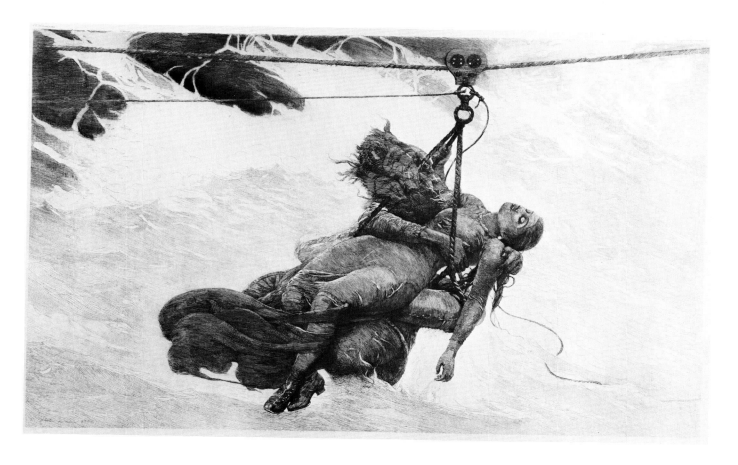

33. SCHOONER AT ANCHOR
 1884
 Black chalk and white body color
 on once blue paper
 16 x 24¾ in. (466 x 632 mm.)
 Signed, lower right:
 Winslow Homer / 84
 No. 1488

Schooner at Anchor belongs to a group of studies Homer made while sailing with the herring fleet on the Grand Banks of Newfoundland. These relatively finished sketches fall between the quick pencil notations that he had collected at Cullercoats and the watercolor studies that he favored for other outdoor work. The choice of chalks—a dry medium— may reflect working conditions on ship-board, rather than an abandonment of watercolor.

A.M.

By simplifying and strengthening the composition of an oil painting completed in Prout's Neck in 1886, Homer created a more dramatic picture with a more universal message. The seascape portrays two men, dressed in oilskins, standing on the deck of a ship and checking their bearings with octants. The sea around them is frothy and rough; the clouds roll fiercely, as if part of a passing storm. Homer made subtle changes in the etching which intensified the picture. He eliminated many background details of masts and railings. Elements are arranged carefully, creating bold juxtapositions of dark and light areas. The etching is cropped on the right; the two men are off center and lean slightly away from the unfathomable void of ocean and sky. This picture describes a more sympathetic relationship between man and nature than is usually found in Homer's *oeuvre*. He typically stressed the overwhelming power of nature and the fragile vulnerability of mankind. These two seamen appear to be in control of their situation. They calmly and skillfully check their instruments, oblivious to the wild weather. One senses that they understand the sea and winds. They symbolize a universal human strength, the timeless yet cautious coexistence of man with the sea.

J.A.G.

42. **Eight Bells**
1887
Etching with remarque on paper
18¾ x 24½ in. (477 x 621 mm.)
Signed in the plate, lower left:
Homer Sculp / Winslow Homer
Sculp. 1887
No. 1479

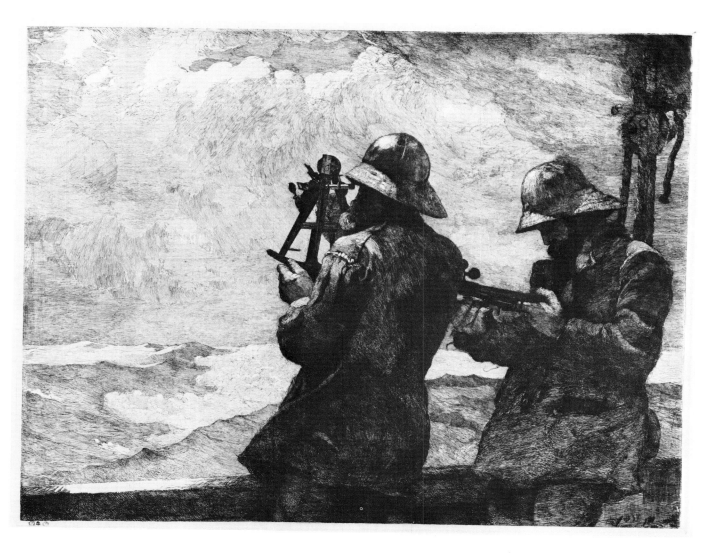

43. MENDING THE TEARS

1888
Etching on paper
15½ x 21⅞ in. (395 x 555 mm.)
Signed in the plate, lower right:
Winslow Homer Sᶜ; in the plate,
upper left: Copyright 1888 by
Winslow Homer N. Y.; upper
right margin: G.W.H. Ritchie,
Imp.
No. 1489

Mending the Tears, executed in 1888, is an adaptation of a watercolor done at Cullercoats, England, six years before. While the central subject remained essentially unchanged between the two versions, Homer boldly altered the basic composition to heighten the significance of the figures in the etching.

The watercolor is a strongly vertical composition, with the young women occupying only the lower half. In minimizing the details of the watercolor's setting, Homer gave the women a greater monumentality in the etching, concentrating his developing skill as an etcher on sculpting their figures in black and white. His touch with the etching needle is more delicate than in his earlier works in the medium (cat. nos. 32 and 41), and he has begun to capture greater variation in the textures of costume and setting.

A.M.

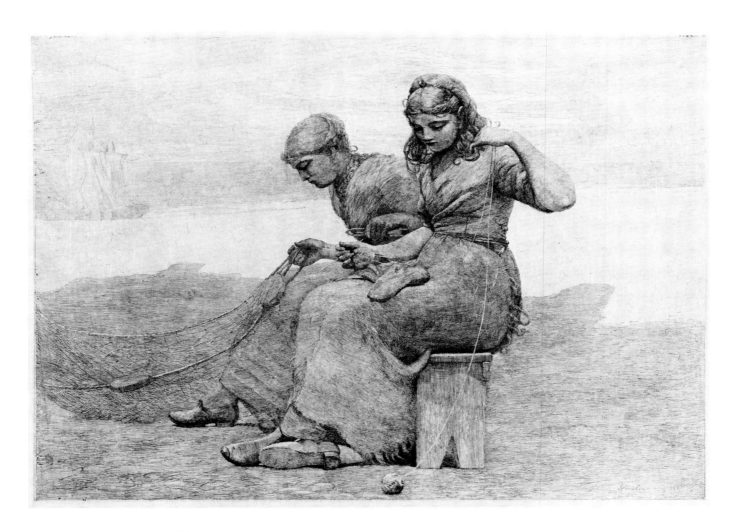

October Day is one of the more anecdotal of Homer's Adirondack watercolors, describing a moment in the unresolved battle between hunter and hunted. Against a vivid background of fiery fall foliage and intense blue-greens of lake and sky, Homer has portrayed a controversial form of hunting known as hounding. At first glance the picture appears tranquil and more like a celebration of the Adirondack autumn colors than a scene of impending violence.

In this particular method of hunting, trained dogs were used to chase the deer into water. Hunters, waiting in boats, would shoot or club the deer to death as it swam out, trying to escape the dogs. This common form of hunting was strongly criticized by many who felt it to be unsportsmanlike.

In *October Day* the deer is seen as it turns away from the hunter hunched in his boat. A black and white dog stands on the far shore in the right of the picture. Homer has indicated the movement of the deer and its change of direction through the rippling water. There is a great deal of tension, emphasized by the triangular arrangement of man, dog, and deer. The deer pulls away from the center, away from the hunter, toward freedom. Homer leaves the viewer hanging. We do not know if the animal will reach safety and survive. It is only clear that the situation will be resolved in seconds.

Homer thoroughly worked this watercolor. The paper is heavily scraped in the rippled areas of the water, bringing the bright white of the paper through, and there is much lifting off and repainting in other areas. A stylistic contrast in the handling of paint in various areas emphasizes the ominous subject of the picture. The delicate, detailed treatment of the deer's head is juxtaposed with the loose, fluid forms of trees and their reflections in the water that surrounds the animal. It is interesting to note the double reflection of the antlers on the water's surface. This may indicate a mistake that Homer tried to correct and revise, or it may be interpreted as an attempt to catch the quickly changing surfaces of the moving water and the effect of sunlight on it.

J.A.G.

45. OCTOBER DAY
1889
Watercolor on paper
13⅞ x 19¾ in. (357 x 501 mm.)
Signed, lower left:
Winslow Homer 1889
No. 770

47. FLY FISHING, SARANAC LAKE
1889
Etching with aquatint on paper
14⅛ x 21¾ in. (360 x 552 mm.)
Signed in the plate, lower left:
Winslow Homer S^c 1889
Copyright; in pencil, lower left
margin: Winslow Homer; lower
right margin: #29
No. 1970.1

Executed in 1889, this etching coincides with Homer's return to the Adirondacks after a fifteen-year absence. *Fly Fishing* repeats a subject which he had used in both oil paintings and watercolors during the 1870s. The lone fisherman, reeling in a fish preparatory to scooping it into the net, sits in a boat on a tranquil lake. Earlier works usually placed the boat and fisherman parallel to the picture's surface, in silhouette. The etching, in contrast, emphasizes a more complicated, oblique view that accentuates the broad beam and curving outlines of the boat and the carefully poised figure of the angler. Background definition is nearly eliminated, focusing attention on the central action.

Homer, an accomplished and devoted fisherman himself, describes a delicate and precise moment in catching the fish: the young man must maintain tension on the line while coordinating the scooping motion of the net in the opposite direction. These opposing motions, set against the strong foreshortening of the boat, provide a highly sophisticated composition which belies the simplicity of the subject.

Lucy Winters Durkin

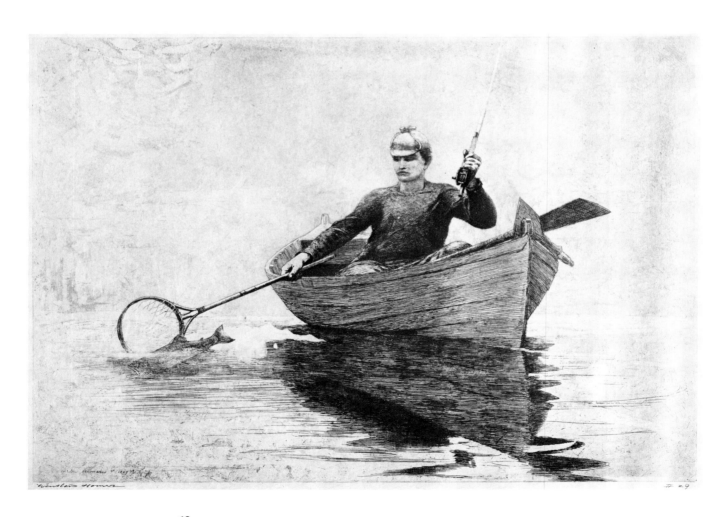

Playing a Fish is one of Homer's few oil paintings that record Adirondack scenes. Although it was probably begun on his second visit, in the summer of 1874, changes are now apparent that indicate it was repainted several years later. In the 1890s Homer painted over the sky and water with thick, dry brushstrokes. These lighter tones reflect his later style, when he was concerned with bold, abstract patterns. The repainted sky, discernible where it overlaps the darker middle section, echoes the value of the flat water. The dark landscape of the distant shore parallels the length of the boat facing the viewer. By reworking the picture, Homer strengthened the design patterns, transforming a serene view of a fisherman on a calm lake into a dramatic abstraction.

When Homer visited the Thomas Baker Farm in Essex County in the summer of 1874, he was accompanied by his friend and fellow painter, Eliphalet Terry. Among the many watercolors Homer produced that summer was a portrait of Terry which now belongs to the Century Association in New York City. It is likely that the portrait served as a model for the oil painting *Playing a Fish*. When Homer repainted the picture, he changed not only the landscape, but also the shape of the boat. It is shorter in the earlier work, with ends angled like those of a rowboat. Around 1890 Homer added wedge-shaped sections which convert the boat into a canoe. The earlier contours are now visible through the overpaint, and they correspond to those of the rowboat depicted in the 1874 watercolor of Terry.

J.A.G.

48. PLAYING A FISH
about 1890
Oil on canvas
11¹¹/₁₆ x 18¹⁵/₁₆ in.
(29.7 x 48.1 cm.)
Signed, lower left: HOMER
No. 773

49. SLEIGH RIDE

ca. 1893
Oil on canvas
14¹/₁₆ x 20¹/₁₆ in. (35.8 x 51 cm.)
No. 771

As a monochromatic winter landscape, *Sleigh Ride* embodies many of the characteristics of Homer's late style. It is a strong, almost abstract composition, in which the power of nature is ominously juxtaposed against the fragility of man. The composition is spacious, with a strong design and minimal detail. The picture was painted around 1893 in Prout's Neck, and Homer's palette at this time was typically cool and dark with shades of gray and blue predominating. The only warmth is in the pale peach streaks of the sled tracks in the snow and the daub of bright red, Homer's favorite accent, which forms the scarf of a figure in the sleigh.

There is no anecdotal quality to this painting. A scenario is only hinted at as the sleigh disappears over a snowy ridge and ominous, dark birds circle in the distance. The human element became less and less important in Homer's late work, virtually disappearing in the 1890s. The raw power and beauty of nature translated through strong designs and abstract patterns became the focus of Homer's late style. His compositions are full of contrasts and juxtapositions, stylistically similar to Japanese woodblock prints. In *Sleigh Ride* bold diagonals and strong light and dark areas combine to create an abstract landscape. The snowy ledge cuts the picture in two, forming an angle which is itself broken by the sleigh. This isolation of a single figure against the background sky occurs frequently in Homer's late work.

J.A.G.

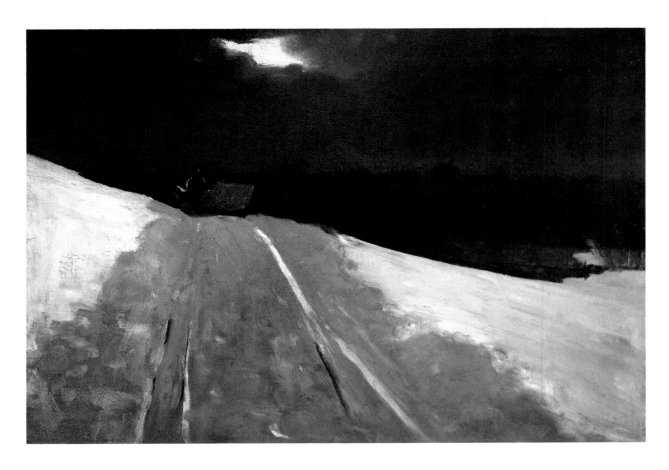

64

Typically Homer stressed the grandeur of nature and its dominance over humanity. In *A Good Pool* the vivid form of the fish looming overhead epitomizes the untamed natural world. The three men appear small and vulnerable as they struggle simultaneously with the rapids and the airborne fish determined to fight ferociously for its life.

Technically this watercolor is representative of Homer's mature style. There is a minimum of detail, restricted to the patterned body of the fish. Color is applied in large areas, first outlined in pencil, with broad fluid brushstrokes. Various techniques were used to achieve desired effects of light and reflectivity. Homer scraped away the paint on the right edge to expose bare white paper and blotted or lifted it off in other areas to reveal multiple layers of color.

In the late 1890s Homer visited the remote Lake St. John region of Canada several times with his brother Charles. The Saguenay River, which flows from the lake into the St. Lawrence River, provided challenges for both fisherman and artist. Although seen from quite a distance, the three men have been carefully individualized by the artist. The figure on the left has been identified as a French-Canadian guide; the central figure is a sport-fisherman; and the third man, in the bow of the boat, is an Indian. The fish is an ouananiche, a type of landlocked salmon found only in the Lake St. John area and famous for its fierce fighting ability. The presence of two lures, one hooked in the fish's mouth and the other visible in the lower right corner, follows an occasional practice in fly-fishing, the use of a line set with multiple hooks to maximize the fisherman's chance of attracting a fish.

J.A.G.

50. A GOOD POOL, SAGUENAY RIVER
1895
Watercolor over pencil on paper
9¾ x 18⅞ in. (247 x 479 mm.)
Signed, lower left:
HOMER 1895; *lower right:*
Ouananiche
No. 1492

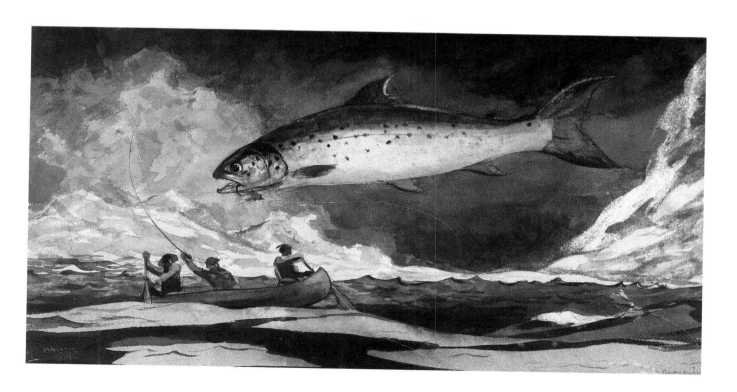

51. SUNSET, SACO BAY
1896
Oil on canvas
23 13/16 x 37 15/16 in.
(60.5 x 96.3 cm.)
Signed, lower right:
HOMER 1896
No. 5

Sunset, Saco Bay, painted in the summer of 1896, was one of Homer's own favorites. Among his most impressionistic works, *Sunset, Saco Bay* depicts a precise moment when the sun dips behind a cloud before slipping over the horizon. The surface of the sea is fiery, painted with broad, loose strokes of the brush. The dark, diagonal mass of rock in the foreground contrasts sharply with the fluid, glimmering surfaces of water and sky. When the painting was exhibited at the Society of American Artists in 1897, critics applauded Homer's other entries in the exhibition but strongly condemned *Sunset, Saco Bay* for the loose handling of paint and bold colors, precisely those qualities that most appeal to us today.

In spite of this negative reception, the picture was immediately purchased by the Lotos Club of New York City with funds designated for the encouragement of American artists. Homer himself had apparently not expected the picture to sell; he had written his friend and patron Thomas Benedict Clarke,

Although I have painted on this up to 3 days of sending it out, I have had it on hand and observed and studied this particular point and picture for the past ten years. This will account for the cost price that I have put on it. It will not sell, but I have some others that will pay me, and make it possible for me to show a work of this merit, which I now call your attention to. P.S. This above, would seem that W. Homer has a great opinion of himself but it is the picture *that I am talking about.*

Sunset, Saco Bay portrays Checkley Point, the southwest corner of Prout's Neck, overlooking the bay. Homer was especially fond of this view, which he saw from his studio, and he painted it often in different seasons and at different times of day. The two women have been identified as Prout's Neck residents Maude Googins Night and Cora Sanborn who also appear dancing in front of the night surf in Homer's earlier painting, *A Summer Night* (Musée du Louvre, Paris). Homer skillfully used the figures of the two women to unify his composition, posing them as extensions of the landscape, to connect the foreground of the picture visually to the background.

J.A.G.

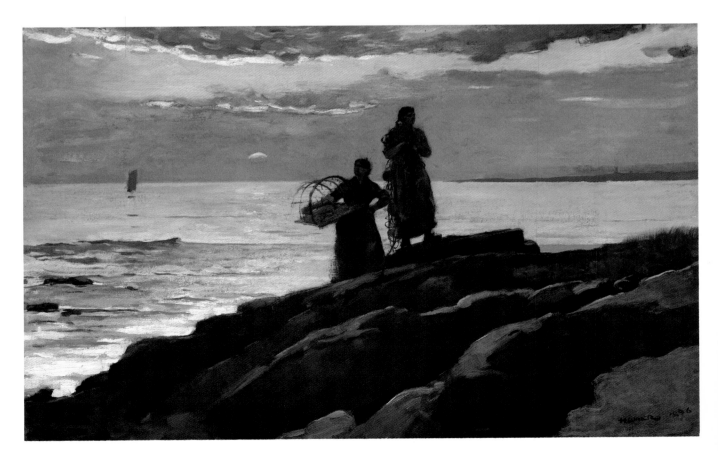

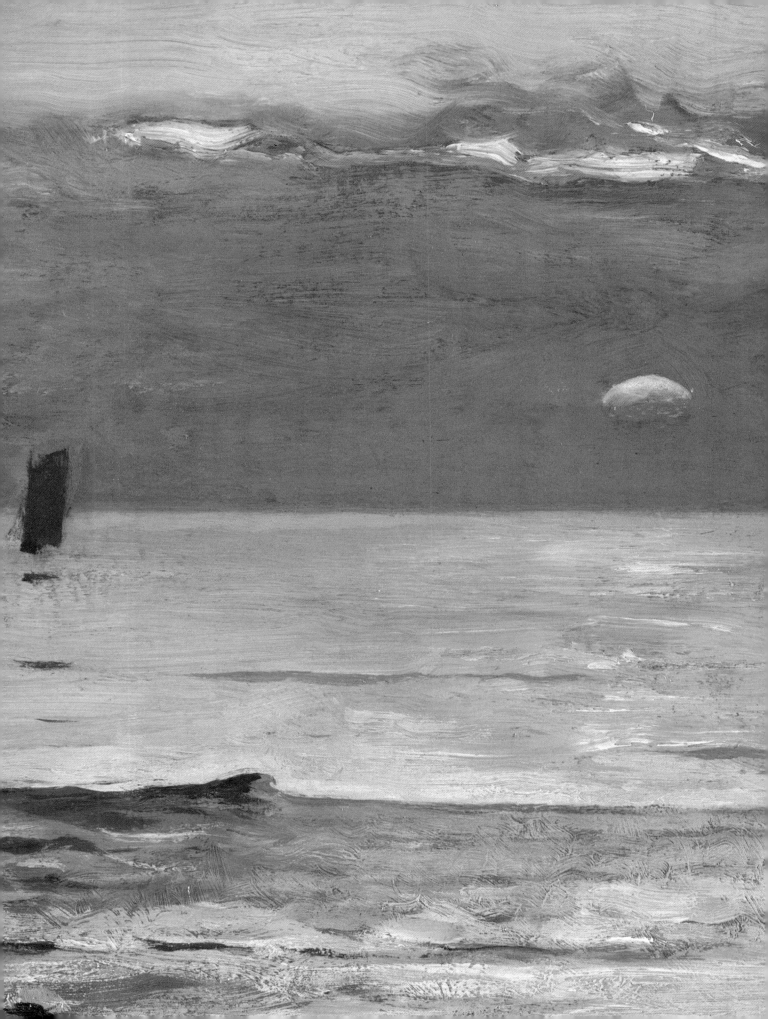

52. FISHING IN THE NORTH WOODS

1896
Chromolithograph after Homer,
printed in oil colors
14¾ x 21 in. (375 x 533 mm.)
Published by Louis Prang,
Boston
No. 985

This nineteenth-century reproduction of a Homer watercolor is exceptional in its color fidelity. Printed by Louis Prang, a Boston specialist in color reproduction and a close friend of Homer's, the print greatly satisfied Homer with its quality. The late nineteenth century saw considerable experimentation in reproduction techniques, particularly in the area of color reproduction, but seldom were such satisfactory results obtained.

A.M.

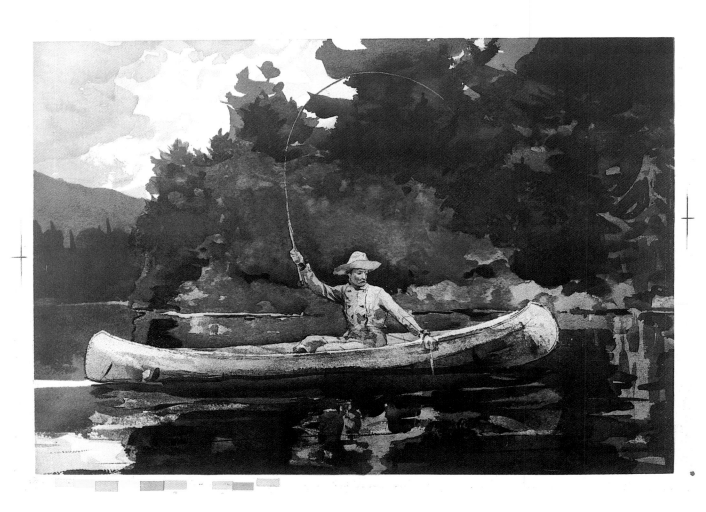

During the 1890s Homer painted a number of exquisitely colored images of trout leaping from the water, seen against the shadowy banks of dark pools, un-molested by man, or in panicked counter-point to the fishermen behind them (see cat. no. 50); but none of those earlier watercolors attained quite the abstraction of *Fish and Butterflies,* in which virtually all indication of spatial depth has been eliminated. Indeed, the inclusion of the butterflies in the same plane with the fish and the extraordinary reversal of the com-mon landscape pattern of light sky above dark water seem deliberately chosen to mock the conventions of spatial differentiation.

Fish and Butterflies is often compared to certain Japanese prints in which brilliantly colored, twisting carp are featured, but the Japanese emphasis on pattern rather than spatial manipulation makes those works unlikely sources for Homer at this point in his art. It is more probable that *Fish and Butterflies* is the direct develop-ment of the earlier leaping fish paintings, perhaps prompted by the stained glass windows featuring fish and lilies designed by his friend John La Farge in the late 1890s.

A.M.

53. FISH AND BUTTERFLIES
1900
Watercolor over pencil on paper
14½ x 20¹¹/₁₆ in.
(367 x 525 mm.)
Signed, lower left:
HOMER. 1900.
No. 775

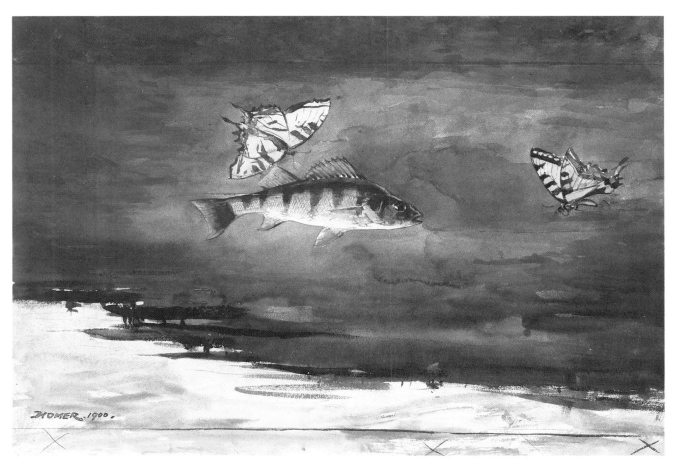

54. EASTERN POINT,
 PROUT'S NECK
 1900.
 Oil on canvas
 30¼ x 48½ in.
 (76.9 x 123.2 cm.)
 Signed, lower right:
 Winslow Homer / Oct 14th, 1900.
 No. 6

Homer knew, and proudly stated, that *Eastern Point* and *West Point, Prout's Neck* were among the finest paintings he had ever created. He had been living in Prout's Neck since 1884 and painting there since 1875, and the pair of pictures completed within two months of each other late in 1900 achieve a summation of more than twenty years' experience painting the meeting of earth and sea. In their powerful complementarity, they celebrate the contradiction of the sea, the infinite mutability of its enduring presence, and they acknowledge the impossibility of capturing the full truth of the sea in any one painting.

Eastern Point and *West Point* do not form a conventional landscape pair in which compositions are reversed like bookends or similar views are shown at dawn and dusk to serve a decorative purpose. Instead, Homer stressed opposing experiences of the natural world: its visual transience and its physical permanence. The dramatic—in truth, flamboyant—*West Point* attempts to capture the intangible magnificence of movement, light, and infinite space, as sunset-tinged water overruns the rocks at landfall. *Eastern Point,* pushing back a colder, heavier sea with the forceful, faceted thrust of land's end, asserts the massive, physical presence of earth and water.

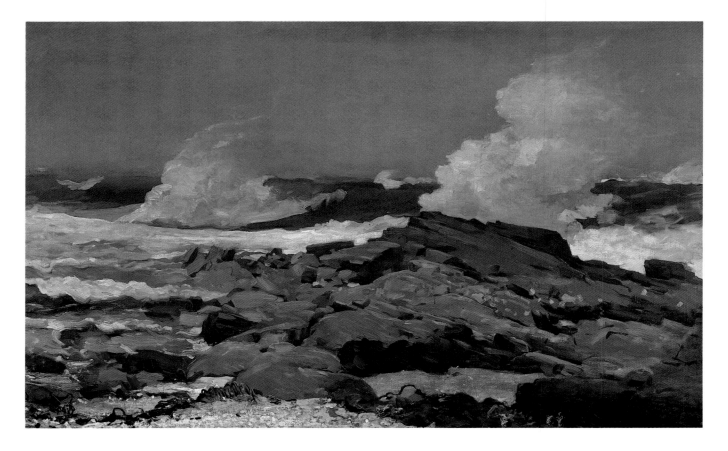

Homer conveys these distinct experiences with the skilled manipulation of his colors and his brushwork. *Eastern Point* is painted with bold, heavy brushstrokes whose direction and weight reinforce the solidity of the rocks, weeds, and waves, while the earthy browns, ochres, and greens seem derived from the very substance of the things represented. The acidic blue-green waves in *West Point,* however, touched through and through with reflections of the sky, are mercurial, without shapes or edges of their own as they flow in soft courses over the rounded rocks. Dry, dragged-out brushstrokes of water dissolve into stone along the right-hand side, while the burst of water rising at the left explodes as steam and foam.

The striated reds and lavenders of *West Point*'s evening sky seem to move ever further away, while the flat, pewter-colored sky of *Eastern Point* weighs down on the water beneath it.

Eastern Point and *West Point* employ the fundamental oppositions of medieval alchemy—earth and water, fire and air, respectively—to characterize physical experience. When the paintings were exhibited together in 1900, their interrelationship was lost amid the harsh criticism leveled at the lurid colors of *West Point.* Until reunited by Robert Sterling Clark in 1941, the paintings hung separately in different collections.

A.M.

55. WEST POINT,
PROUT'S NECK
1900
Oil on canvas
30¹/₁₆ x 48⅛ in.
(76.4 x 122.2 cm.)
Signed, lower right:
HOMER 1900.
No. 7

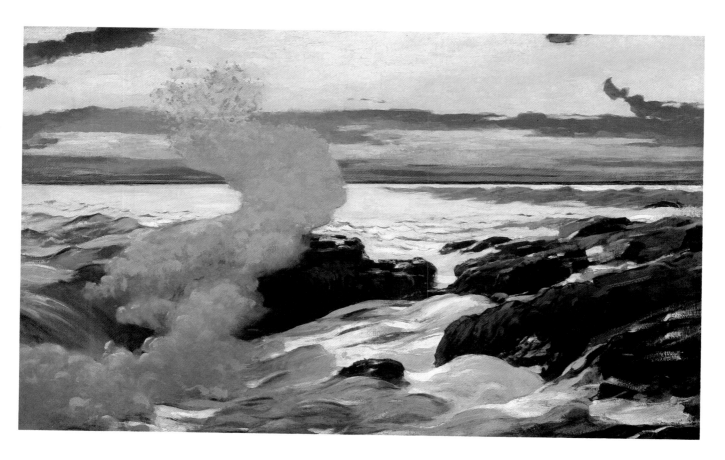

56. OSPREY'S NEST

1902
Watercolor over pencil on paper
21½ x 13⅝ in. (547 x 345 mm.)
Signed, lower right:
HOMER 1902; *verso: Eagles*
Nest / Roberville / [Pg] /
Canada / No. 6
No. 1502

Winslow Homer's vision of man's position in and relationship to nature is expressed in this watercolor as strongly as in many of his more violent scenes of life on the Saguenay rapids. The two men stand in awe of the great birds they have surprised, much as Homer stood in awe of the power inherent in the natural world. This attitude toward nature, together with a loose calligraphic style and a monochromatic palette, links *Osprey's Nest* stylistically to other watercolors Homer painted in Quebec.

Osprey's Nest depicts two men pulling a canoe toward shore, crouching as they watch a pair of ospreys soar above them

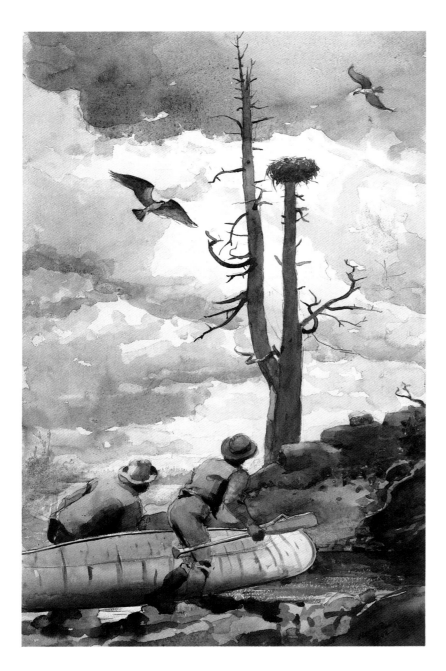

toward their nest atop a dead tree. The composition was painted quickly with loose, watery brushstrokes. The right leg of the nearest man is unfinished; only the outline has been sketched in pencil. The predominant shades are gray and brown, with the exception of deep green vegetation on the river bank in the lower right and a daub of bright red, a bit of shirt visible beneath the vest of the nearest man. Homer delighted in details such as this. Focal points in his watercolors and oils are frequently small areas—scarf or shirt—of vivid red. Almost overwhelming this bright fragment is the sky, masses of gray wash overlapping each other and broken by untouched areas of white paper. Homer achieved different levels of translucence in the sky by blotting or lifting out the wet paint. The foreground is abstract and calligraphic. Heavy strokes of paint overlap to create the irregular shapes of rocks. The effect is impressionistic; light and shadow together with quick, spontaneous brushstrokes determine the forms of Homer's objects.

Osprey's Nest is atypical of Homer's Canadian subjects. Usually he depicted active scenes such as guides shooting the rapids of the Saguenay River or fishermen casting for the feisty ouananiche salmon or portaging their boats along the wooded banks of the river. *Osprey's Nest* was painted on one of Homer's many visits to Quebec. Beginning in the summer of 1893, Winslow and his brother Charles traveled to Canada several times to fish, hunt, and paint. Previously they had frequented the more accessible Adirondack region of northern New York State, but as that area became more popular with summer tourists the Homers decided to explore the more remote wilderness of Canada.

This watercolor was formerly known as *Eagle's Nest* due to incorrect identification of the birds. The osprey is a large bird of prey—related to and often confused with the bald eagle—which lives on fish that it catches with its feet. It is recognized by its white belly, dark back, and angled or crooked wings with dark wrist patches.

J.A.G.

Summer Squall combines the sea and sky of a storm Homer had witnessed and recorded from Checkley Point in the mid-1890s with a very real Prout's Neck rock some distance further down the shore and a boat based on the cobles of Cullercoats, England. Although he was so intensely committed to careful observation of natural truth that he had a portable studio built to allow him to work at the edge of the sea in any weather, *Summer Squall* makes clear that Homer's use of natural truth was a most complicated one.

Unlike the French Impressionists with whom he is too often compared, Homer did not regard absolute fidelity to the specific details of a limited visual experience as the measure of artistic truth. Rather, for Homer, truth lay in the power of a work of art to evoke visually all the complexities of experience. He was willing to set aside a picture for years, until he was certain how to obtain the effect he desired (as he did with *Summer Squall*, which was not completed until 1904). If the effectiveness of a painting required geographical manipulation on the part of the artist, Homer obliged.

Thus the coloristic truth of *Summer Squall*'s sea and sky, merging in a striking blue-green at the horizon, is matched with elaborate distortions of scale that pair the too-far-distant boat with the exaggerated touches of paint evoking droplets of spray across the foreground of the painting. Homer's summer squall had been a physical as well as a visual experience, and it included a measure of concern for the occupants of a small boat caught in a sudden storm. The emotional and reflective components that the Impressionists would have eliminated from painting were as vital to Homer's experience as the purely visual.

A.M.

57. SUMMER SQUALL
1904
Oil on canvas
24¼ x 30¼ in. (61.6 x 76.9 cm.)
Signed, lower left:
HOMER 1904
No. 8

GENERAL WORKS AND BIOGRAPHIES:

LLOYD GOODRICH. *Winslow Homer.* New York: Whitney Museum of American Art and the Macmillan Co., 1944. The first thorough study of Homer by the leading American Homer scholar. Goodrich is presently preparing the comprehensive catalogue of Homer's work. Available in many libraries.

JOHN WILMERDING. *Winslow Homer.* New York: Praeger Publishers, 1972. The successor to Goodrich, also widely available.

JAMES THOMAS FLEXNER. *The World of Winslow Homer, 1836-1910.* New York: Time-Life Books, 1969. Excellent reproductions accompanied by readable text which focuses on Homer in the context of his contemporaries.

WATERCOLORS:

HELEN COOPER. *Homer Watercolors.* Washington, D.C.: National Gallery of Art, 1986. Catalogue of the most recent major Homer show.

PHILIP C. BEAM. *Winslow Homer Watercolors.* Brunswick, Maine: Bowdoin College, 1983. Fine exhibition catalogue.

HEREWARD LESTER COOKE. "The Development of Winslow Homer's Water-Color Technique." *Art Quarterly,* 24:2 (Summer 1961), 169-94. Cooke studies the many different methods with which Homer experimented during his career.

INTERPRETATIONS OF HOMER'S WORK AND SPECIALIZED STUDIES:

CHRISTOPHER KENT WILSON. "Winslow Homer's *The Veteran in a New Field:* A Study of the Harvest Metaphor and Popular Culture." *American Art Journal* (Autumn 1985), 3-27. An analysis of how contemporaries would have interpreted one of Homer's most moving paintings.

HENRY ADAMS. "Mortal Themes: Winslow Homer." *Art in America,* 71:2 (February 1983), 112-26. An interesting examination of themes of death in Homer's works.

PHILIP C. BEAM. *Winslow Homer at Prout's Neck.* Boston: Little, Brown & Co., 1966. A specialized study of Homer's years in Maine, where he painted most of his oils of the sea.